ART MADE EASY

Easy Watercolor

KRISTIN VAN LEUVEN

Brimming with creative inspiration, how-to projects, and useful information to enrich your everyday life, quarto.com is a favorite destination for those pursuing their interests and passions.

First published in 2022 by Walter Foster Publishing, an imprint of The Quarto Group. 100 Cummings Center, Suite 265D, Beverly, MA 01915, USA. **T** (978) 282-9590 **F** (978) 283-2742 **www.quarto.com** • **www.walterfoster.com**

Walter Foster Publishing titles are also available at discount for retail, wholesale, promotional, and bulk purchase. For details, contact the Special Sales Manager by email at specialsales@quarto.com or by mail at The Quarto Group, Attn: Special Sales Manager, 100 Cummings Center, Suite 265D, Beverly, MA 01915, USA.

ISBN: 978-1-60058-949-2

Digital edition published in 2022
eISBN: 978-1-60058-950-8

Proofreading by Manu Shadow Velasco, Tessera Editorial

Printed in China
10 9 8 7 6 5 4 3 2 1

ART MADE EASY

EASY WATERCOLOR

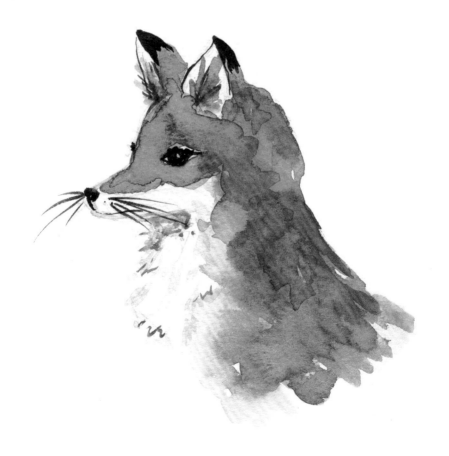

TABLE OF CONTENTS

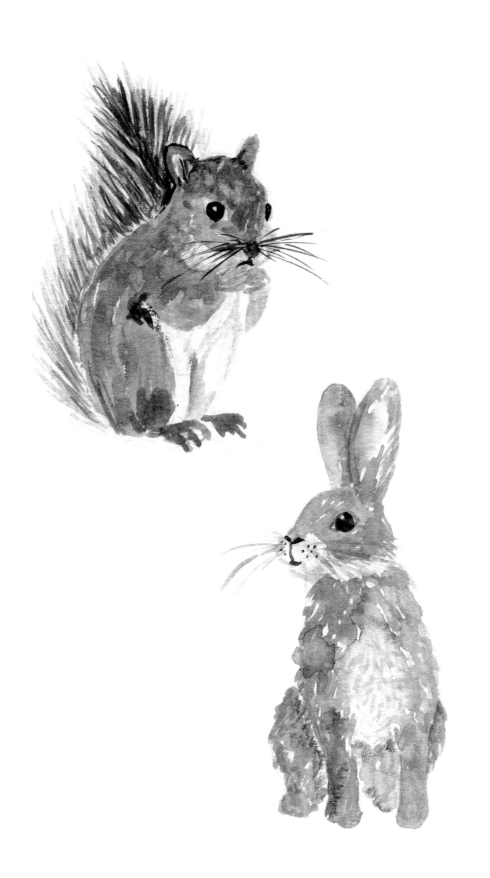

GETTING STARTED

INTRODUCTION

Whether or not you call yourself an artist, you are one—creativity is an inherent human trait. It may look different from person to person, but the capacity for artistic expression is in each of us. Sometimes it just needs a little push—and the permission to explore.

Nothing is perfect, and watercolor paint reflects this beautiful reality. Watercolor's light and airy quality uniquely sets it apart from other types of paint. This fluid medium requires some practice to master, but you don't need to have any experience to get started. If you can hold a paintbrush, you can learn how to paint gorgeous, modern watercolor artwork!

In the pages of this book, you'll discover the essential tools of the trade, basic brushstrokes, beginner painting and color mixing techniques, and simple tutorials that show you how to paint everything from shapes and patterns to fresh botanicals and abstract landscapes. With a few brushstrokes, you can quickly capture the essence of any subject.

Whether watercolor painting is a hobby, a new creative entrepreneurial venture, or just a way to play, as you work your way through this book, you will learn the basics to build upon as you develop your creative skills and revive your inner artist.

So pick up your brush, and let's get started!

SUPPLIES

The supplies you use are very important. The higher the quality of your supplies, the easier it will be to paint without frustration and create the look you want. The tools and materials listed here will help you get started in your journey as a watercolor artist.

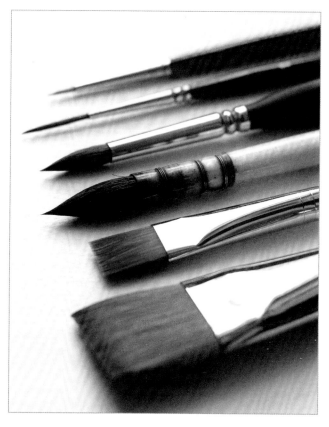

Round brushes are the most commonly used brush for watercolor because of the wide variety of ways in which they can be utilized.

Use flat brushes to create sharp lines, geometric shapes, and paint large surface areas.

BRUSHES

The ideal brush holds water well, maintains a fine point, distributes paint easily, and returns to its shape after use.

The hair on watercolor brushes can be animal (typically sable), synthetic, or a mixture. Sable is the highest quality and performs the best; therefore, it can be expensive. Synthetic bristles are made to mimic the qualities of sable and provide a more affordable option. A combination brush contains sable and synthetic hairs to increase the performance that synthetic lacks while still providing affordability.

Brushes come in a range of sizes. The lower numbers (0, 2, 4, etc.) have smaller bodies, and the higher numbers (12, 14, 16, etc.) have larger bodies. The size(s) you choose will depend on the scale of your painting.

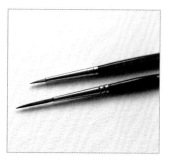

Use thin, long brushes for small details, long lines, and script.

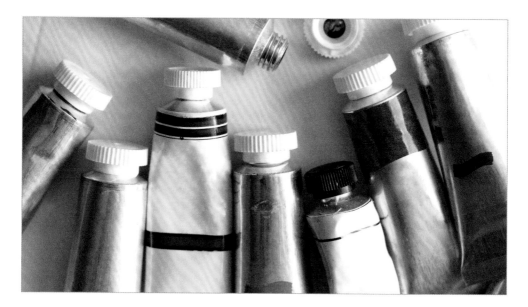

PAINT

Watercolor paint consists of two main ingredients: gum arabic (the binder) and powdered pigment (the color). Student-grade paint contains cheaper pigment and more fillers, while artist-quality paint contains superfine pigment with high permanence.

Student-grade paints are great to start with, especially if you're new to watercolor and want to practice. However, many beginners become frustrated working with student-grade paints because they can't produce highly pigmented colors, the flow is restrictive, and they fade in direct light. Aim to get the highest-quality paints you can afford, even if you buy them slowly over time.

Pans of watercolor paint are more often available in student-grade quality. You can find artist-quality pans, but most professional artists use pans for painting outdoors and while traveling. Artist-quality tubes contain plenty of paint that will last a decent amount of time, and they are also easier to use.

PALETTE If you're working with tube paints, you'll also need a palette. Fill each well with individual colors of paint. Keep similar colors next to each other for ease of use.

PAPER

The most important thing to understand about paper is the weight. Regular printer paper will cave and buckle if water is applied. Thick watercolor paper with enough weight can hold water without buckling. The standard weight for watercolor paper is 140-lb.

Watercolor paper is available cold-pressed (textured), hot-pressed (smooth), and rough. Cold-pressed paper has ridges and texture, which allow the paper to hold more water and keep it in place. Hot-pressed paper is smooth and non-textured, requiring less water for paint to flow easily. Cold-pressed paper has a great texture while handling lots of water. Hot-pressed paper works well for watercolor lettering and illustrations.

Water flows well on 100% cotton paper. If the paper is not purely cotton, it can puddle in unexpected areas while painting. Some artists prefer the look of paper that is not purely cotton, so try out a few different kinds to see what you like best.

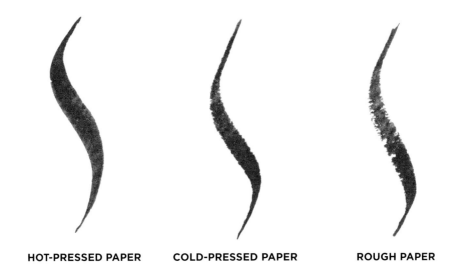

HOT-PRESSED PAPER COLD-PRESSED PAPER ROUGH PAPER

MISCELLANEOUS SUPPLIES Before you begin painting, gather these other useful materials.

WATER

It's helpful to use a water container that has two separate sides. That way you can rinse cool colors in one half and warm colors in the other half so the hues won't mix.

MASKING FLUID

Masking fluid protects the white of the paper from watercolor paint. Use it to protect areas of your painting or bare paper where you don't want paint to go.

PAPER TOWELS

Paper towels are useful not only for cleaning up your workspace and brushes but for creating interesting texture in your watercolor paintings.

MASKING TAPE

Masking tape is a great tool to have on hand for creating crisp lines while you're painting. Like masking fluid, the tape protects the paper, or dry paint on the paper, from wet watercolor paint.

PAINTING BASICS

Follow these tips and techniques as you explore watercolor painting. Even if you've never painted before, with a bit of practice, you'll soon find yourself becoming more comfortable with this fun and beautiful medium!

Loading the Brush with Water

PERFECT

To fill the brush with just the right amount of water for painting, rest the bristles quickly on a paper towel after dipping in water.

TOO WET

When you simply dip a paintbrush into your water container, it holds a great deal of water. While it is too much water for painting, this amount of water is useful for diluting paint for lighter washes over larger areas of paper.

TOO DRY

If you dry the brush too much on the paper towel, it may be too dry for regular painting. A "too dry" brush can be used for creating textures and intricate details, however.

Loading the Brush with Paint

When loading your brush with paint, you want to have the "perfect" amount of water on the bristles. (See "Perfect," page 12.) Dip the paintbrush into the color you want, and use the palette to mix paint and apply more water if needed.

If the paint is very thick, it won't flow as smoothly on the palette. For looser paint flow, dip the paintbrush in water and add it to the color to thin.

A medium amount of paint will have just the right amount of flow without the pigment being too watered down.

Very watered-down pigment will have lots of flow and will puddle on the palette.

If the paint on your palette is too watered down, add more paint. If it's too thick, add more water. Play around with the consistency until you find what best fits your needs and style.

Techniques

You can achieve a wide range of looks and textures with watercolor paint. Practice the following techniques to get comfortable with your paints and brushes, and refer to this section as you begin painting if you need a refresher on how to create the look you want.

FLAT WASH

Paint the area with plain water.

Apply color evenly, allowing it to spread across the wet paper.

Avoid interfering with the wash so it maintains the flat appearance as it dries.

GRADATED WASH

Paint the area with plain water.

Apply a heavy amount of pigment to the brush, and place it at the edge of the wet area of paper.

Allow the paint to gradually spread through the wet area so the color is dark on one side and gets lighter as it spreads.

VARIEGATED WASH

Paint the area with plain water.

Add random drops of one color, leaving white space between.

Add drops of another color in the white space, allowing some blending but ultimately keeping the colors true.

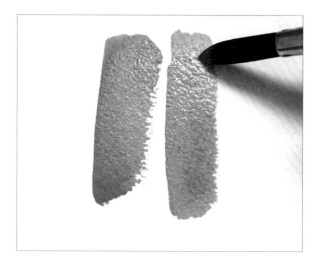

WET-ON-DRY This is the most basic technique. Take a brush loaded with paint, and paint directly on a dry piece of paper.

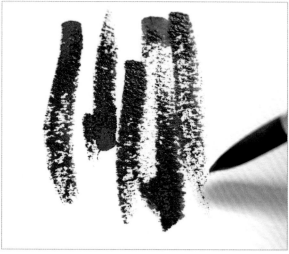

DRY BRUSH Dry a wet brush with a paper towel before dipping it into slightly diluted paint. Apply paint to the paper, letting the dryness create lots of texture.

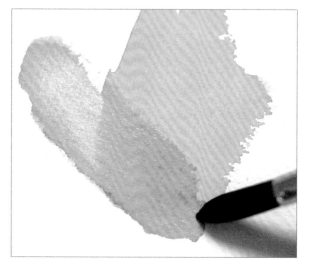

GLAZING Apply a layer of solid watercolor. Let it dry completely, and then paint another color on top of it. This technique allows you to layer watercolor paint without the colors bleeding together.

WET-ON-WET

Paint an area with solid color.

While the paint is still very wet, drop in another color with a good amount of water.

Allow the paints to bleed together while still maintaining their true colors.

DRY-ON-WET

Paint an area with solid color.

While the paint is still glistening wet, drop in another color with a dry brush.

The color will bleed some, but for the most part, it will stay where you drop it and develop fuzzy edges.

BLENDING

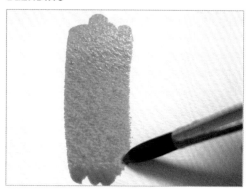

Paint an area with solid color.

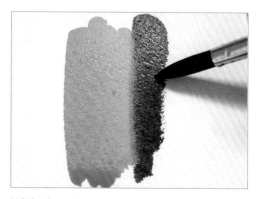

While the paint is still very wet, apply a different color right next to the first, allowing the edges to touch.

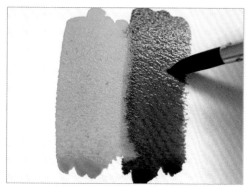

This technique allows the paints to bleed into each other and mix where they meet to create a new color.

PRESSURE & LIFTING

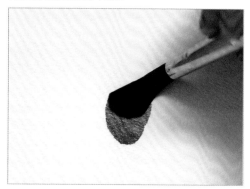

With a fully loaded brush, apply pressure to the body of the bristles on the paper.

Using a quick sweeping motion, lift at the end.

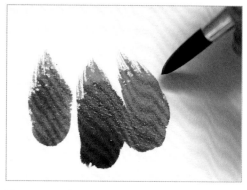

You can apply pressure and lifting as one technique, or you can use each step as an individual painting technique.

HARD & SOFT EDGES

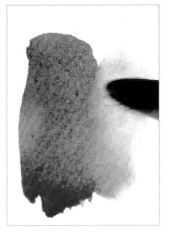

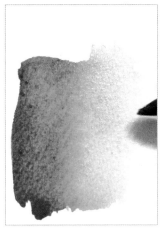

Paint an area with watercolor paint. If you let the paint dry in this stage, the edges are *hard*.

For *soft edges*, apply water to the edge until it blends more naturally.

The result is a subtle gradation of color that increasingly gets lighter as it moves out.

BACKRUNS

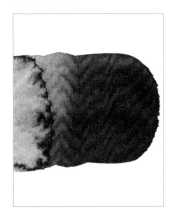

Backruns, or *blooms*, create interest within washes by leaving behind flower-shaped edges where a wet wash meets a damp wash. First stroke a wash onto your paper. Let the wash settle for a minute or so, and then stroke another wash within (or add a drop of pure water).

TILTING

To pull colors into each other, apply two washes side by side and tilt the paper while wet so one flows into the next. This creates interesting drips and irregular edges.

SPATTERING

First cover any area you don't want to spatter with a sheet of paper. Load your brush with a wet wash and tap the brush over a finger to fling droplets of paint onto the paper. You can also load your brush and then run the tip of a finger over the bristles to create a spray.

Removing Paint

Although you cannot completely "erase" paint from the page, there are a couple of techniques you can use to remove paint while it is still wet.

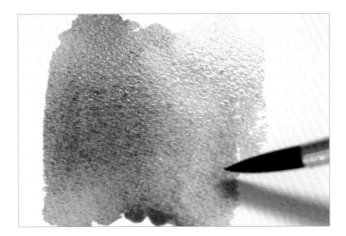

PAPER TOWEL

Begin by painting an area with watercolor.

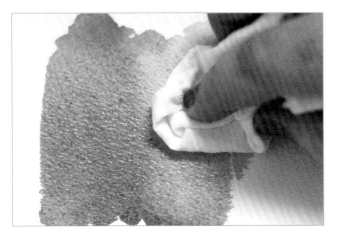

Dab a piece of paper towel lightly over the area to remove some color.

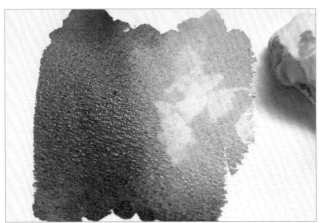

The paper towel absorbs some, but not all, of the color.

PAINTBRUSH

You can also sweep a dry paintbrush over the painted area.

The paintbrush doesn't pick up quite as much pigment as the paper towel, leaving behind a softer, more subtle area of lifted color.

You can use these techniques to try to correct mistakes, but they are also great tools to use as part of your painting process to create interest and texture in your artwork!

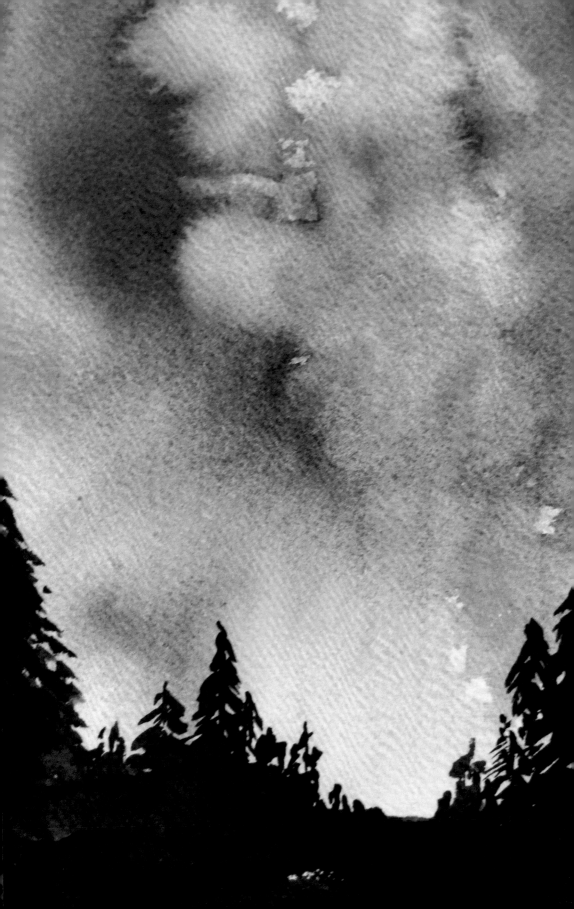

EXPLORING COLOR

COLOR THEORY

Color theory is the guide by which color is mixed and organized. The color wheel is the traditional structure for organizing color into three categories: primary, secondary, and tertiary.

PRIMARY

The primary colors are red, yellow, and blue. These three colors cannot be created by mixing other colors. All other colors are a result of blending primary colors.

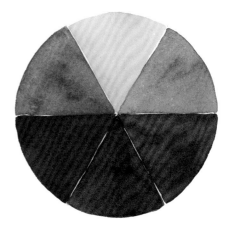

SECONDARY

The secondary colors are green, orange, and purple. These colors are created by mixing two primary colors. Yellow + Blue = Green. Red + Yellow = Orange. Blue + Red = Purple.

TERTIARY

The tertiary colors are yellow-orange, red-orange, red-purple, blue-purple, blue-green, and yellow-green. These colors are formed by combining a secondary color with a primary color. For example: Yellow + Green = Yellow-Green.

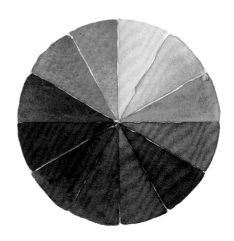

Color Harmony

Color harmony refers to color arrangements that are pleasing to the eye and make sense visually and artistically. When colors are used in harmony, they create balance and interest. When colors are used out of harmony, the result is visually confusing and chaotic. Your goal is to create art, using hues from the color wheel, that visually makes sense and is interesting.

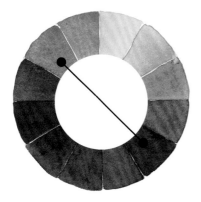

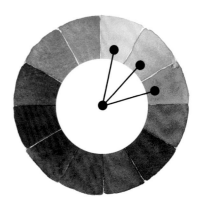

COMPLEMENTARY

A complementary color scheme creates high contrast. While creating a very vibrant look, they must be used well to avoid overstimulation and chaos. For example, red and green are complementary, but using a softer value of red in a painting that uses this color scheme will avoid visual confusion.

ANALOGOUS

Analogous colors are any three colors that are side by side on the color wheel. For example: yellow, yellow-orange, and orange. Colors next to each other on the color wheel blend easily together, so they make sense to the brain. One color usually dominates.

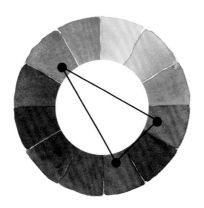

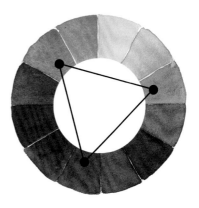

SPLIT-COMPLEMENTARY

This is an adaptation of the complementary color scheme. The use of these colors produces high contrast with less conflict. For example: green, red-purple, and red-orange.

TRIADIC

An arrangement of triadic colors creates high contrast, even when using lighter color values. This combination is very vibrant, and usually one color dominates while the other two support.

COLOR MIXING

Color mixing is the process of combining colors to create a new color. Learning to create the right hue is an important skill you'll use for every project. There are three ways you can mix color: on the paper, on the palette, and by glazing.

PAPER

If you're okay with the primary colors not being completely blended, you can mix colors right on watercolor paper. Typically this approach isn't completely even. This example shows a mixed green, but note how some places look more yellow or blue.

PALETTE

To create even and consistent color, mix colors on your palette before dropping them onto the paper. With this technique, you can completely control the color balance before applying it to paper.

GLAZING

Glazing is a method of applying layers of watercolor over each other. This is a great way to create the color you want, but also add dimension with glimpses of the colors underneath.

Color Mixing Chart

It's important to not only know how to mix other colors from primary colors but to also know how to mix the specific paint colors on your palette. Most watercolor artists have a wide variety of colors on their palette, not just the primaries. It's very valuable to make a chart of all the different hue combinations your paints can create. Follow these tips to create your own chart.

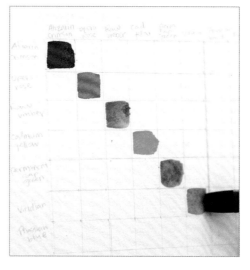

Using a ruler, chart and draw squares based on the number of paints you will use in your chart. This example uses eight colors, which makes 64 squares. Then write the names of the colors you will be using along the left side and the top in the same order.

The middle diagonal line is the "pure color," where the name of the paint is the same on the side and top. Paint this row first.

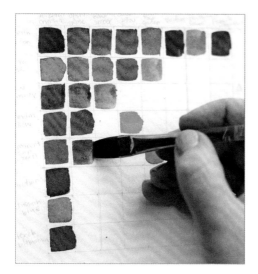

There will be two places on the chart where the same color combination meets. Remember: the color listed on the left is the dominant color. Use that color as the base, and add a little of the color listed at the top to create the hue for each square.

To save paint when making your chart, mix both color combos at the same time. For example: When the dominant color is opera rose and the additive color is viridian, add a little viridian to opera rose on your palette, and then place that color in its square. Next take that paint mixture and add viridian until it becomes the dominant color, and then drop that color into its square.

Isn't the chart amazing? You can see all the different colors that can be created with your palette, and you may even find some combinations that pleasantly surprise you!

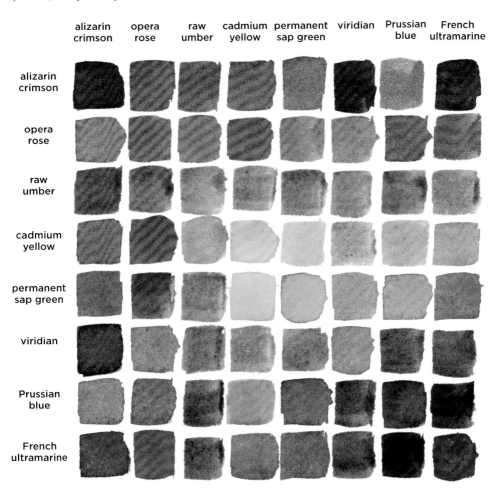

raw umber + opera rose

viridian + raw umber

French ultramarine + viridian

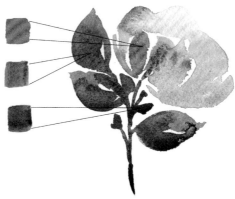

When you're painting, search your chart for the colors you want to use. This allows you to pinpoint the exact combination quickly, without wasting paint in the effort to achieve it.

To explore the color variations within a combo, as well as their value, create a smaller mixing chart. Paint the top and bottom rows with 100% unmixed color, the middle row with a 50/50 mix, and the other two rows with more of the pure color each row is closest to.

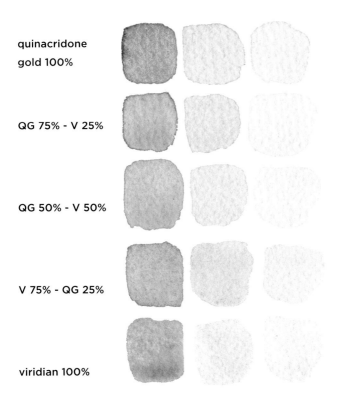

quinacridone gold 100%

QG 75% - V 25%

QG 50% - V 50%

V 75% - QG 25%

viridian 100%

Example: Place quinacridone gold at the top and viridian at the bottom. Mix both together to create an even mixture for the middle row. For the row closest to quinacridone gold, add more yellow. For the row closest to viridian, add more green. Add water to the colors to create the lighter values in the chart.

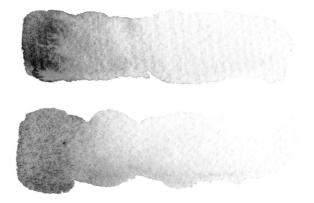

Value is the relative lightness or darkness of a color. To make a color value lighter, add water. To make a color value darker, add pigment.

To help determine the value of a color, compare it to the grayscale. The grayscale helps you determine which shade is closest in value to your color. For example, yellow matches up with the lighter values of gray, and purple matches up with the darker values. When painting, values are an important part of making the overall piece make sense.

dark **medium-dark** **medium** **medium-light** **light**

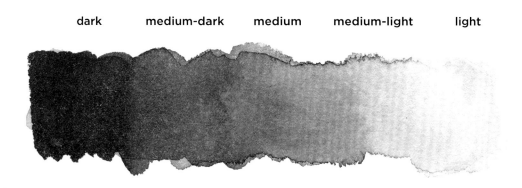

There are five basic values: dark, medium-dark, medium, medium-light, and light. Values are easier to see in grayscale. It's important to train your eye to see the values in color so your paintings look accurate.

You can change the value of a color by either lightening it with water or darkening it with pigment.

To understand grayscale and value better, compare a picture in full color and black and white. Converting a picture to black and white allows you to better see the light, medium, and dark values.

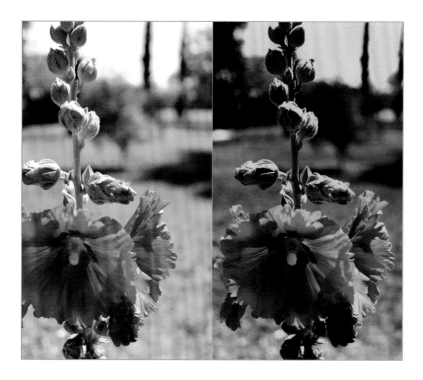

In the example below, you'll find that layering different shades of gray can help you see the color values in the picture on above. You'll see where both the darker shades and the bright, almost-white shades are. Using this technique helpful before painting this piece in color because you can better visualize where the dark color values are.

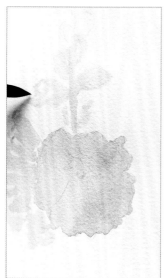
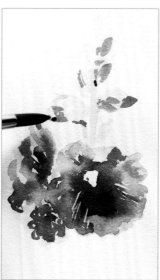
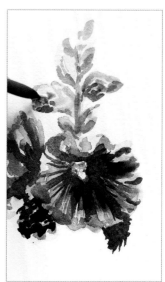

Black & White

Painting in black and white not only helps you practice and learn how to understand color values, but it also creates a pretty, monochrome aesthetic.

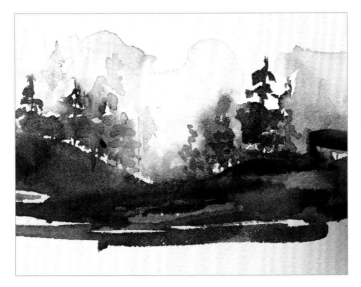

Using different values of black, you can create a monochrome painting with depth and dimension.

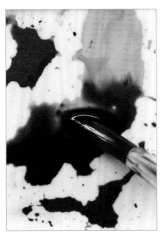

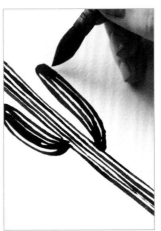

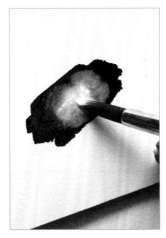

Use your new color mixing skills to create black by mixing all three primary colors until you find the hue you want. This mixing technique produces more dimension, with blue, red, and yellow undertones.

Use the white of the paper as much as possible. It's hard to add white back into a painting, so you must either paint around the areas you want to keep white or use masking fluid.

White watercolor, if used at all, should be used sparingly or only for certain techniques. A perfect instance for using white paint is when you want a color to be opaque, or less see-through. You can add white to any color to achieve this, and adding it to black hues creates lovely, opaque, cloudy grays.

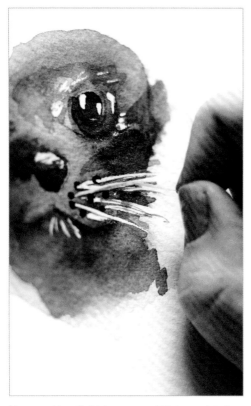

Use masking fluid (see page 50) to maintain perfect whites while using other hues freely.

White watercolor helps makes the perfect opaque gray for this moon.

Use white watercolor straight from the tube, without adding water, to apply smaller details.

GET CREATIVE:
COLOR EXPLORATIONS

Color theory, which may seem simple, is a vital tool for art—especially watercolor! As you learned on pages 22–23, red, yellow, and blue are the primary colors, and combining these colors in different forms creates the color wheel. Colors directly across from each other on the wheel are complementary colors.

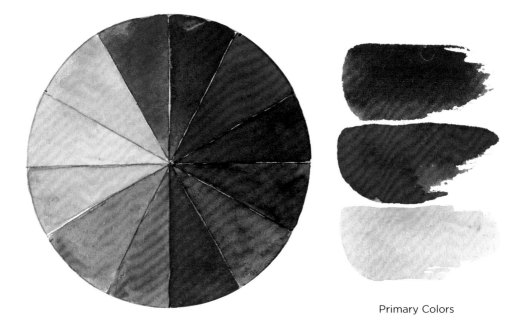

Primary Colors

Assignment

1. Start by getting to know the primary colors on your palette. Try to create a complete color wheel using only these three colors to mix all the other colors.

2. Mix different combinations of colors on the wheel from your palette. What happens when you mix complementary colors?

3. Try painting a picture with bold, bright colors from the color wheel, and then paint the exact same picture using colors muted by their complements.

Adding different ratios of paint can produce
a wide range of hues from only two colors.

Here are two mixed sets of complementary colors: red + green and blue + orange. When the colors are mixed just right, you get a muted, toned-down version of these colors.

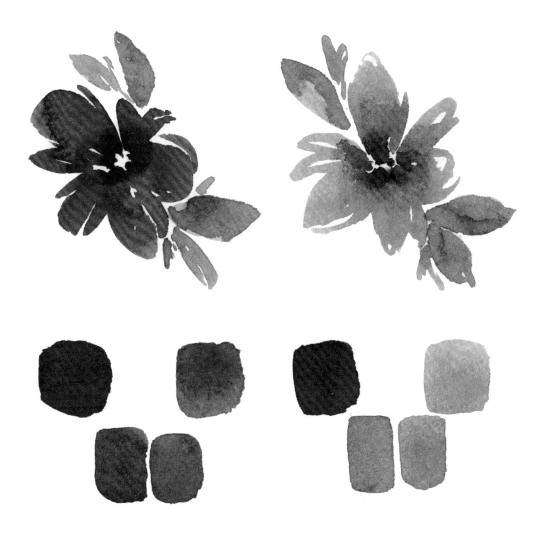

Bold and bright colors
from the color wheel

Muted colors toned down
with complementary colors

A color's complement is the ideal color choice for
creating accurate textures and shadows on an object.

GET CREATIVE:
FOUR PALETTES

Sometimes with art, you can get too comfortable in your habits and techniques and forget to branch out. One area in which this is most true is color palette. You might find you tend to use lots of greens, blues, and yellows, for example, but sometimes you'll want to portray a different feeling in your painting.

The color tones in a painting have a direct effect on how the viewer perceives it. Bright and bold is fun and daring, while cool and muted feels calm and organized.

Assignment

1. For this exercise, pick anything you would like to paint. Choose something simple, like a piece of fruit, a favorite animal, or a flower.

2. First, paint with a cool-toned palette: blues, purples, and deep greens (opposite page, top left).

3. Second, paint with a warm-toned palette: reds, yellows, and oranges (opposite page, top right).

4. Third, paint with a mixture of both cool and warm tones, but keep it bright: blues, yellows, reds, and greens (opposite page, bottom left).

5. Lastly, paint again with a mixture of cool and warm, but mute the colors by adding their complements: blues (add orange), reds (add green), and so on (opposite page, bottom right).

6. This exercise will help you see different emotional outputs for the same scene based on color alone. You might be surprised by which colors you like best!

BRUSHSTROKES & SHAPES

BRUSHSTROKES

Mark-making is the creation of shapes, textures, patterns, and lines to make art. In watercolor painting, there are many kinds of paintbrushes you can use to make marks. Each brush has a purpose and produces a different brushstroke. Let's explore some ways to use brushes for mark-making and the different marks brushes can make!

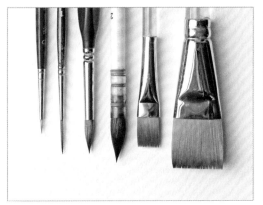
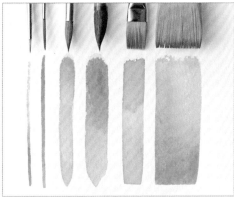

Use different brushes to practice creating the variety of brushstrokes covered in this section.

To create full brushstrokes, apply pressure on the brush to press the full body of the bristles against the paper.

To create thin brushstrokes, apply light pressure on the brush to touch just the tip of the bristles to the paper.

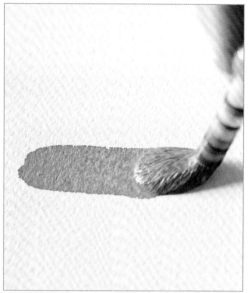

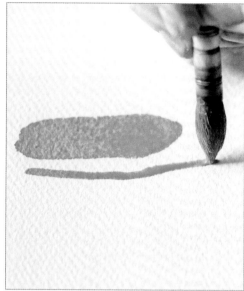

Load the mop brush with paint, and use light pressure to press the full body of the brush onto the paper. Isn't that brushstroke beautiful?

Now, using just the tip of the mop brush, apply barely any pressure to create a very thin line. The contrast between the strokes is amazing!

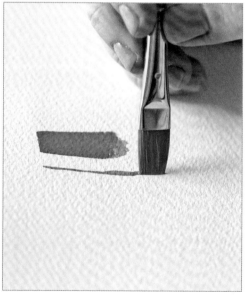

Load a flat brush with paint and use light pressure to press the body of the brush to the paper. A flat brush makes a beautiful hard-edged stroke in comparison to the soft round stroke the mop brush creates.

The flat brush also creates beautiful thin lines when you use just the tip of the bristles.

The way you grip the brush also has a major impact on your brushstrokes. Check out the examples below to see how adjusting your grip changes the way you use the brush.

Use a low grip on the brush to paint precise details. Finger stability near the bristles gives you more control.

Use a higher grip to paint more freely and flowing. This grip doesn't provide the same amount of stability and is perfect for loose painting.

Every brush, whether you use the tip or the body, can create a wide variety of marks. This example shows the results of three different brushes: a flat, a round, and a rigger. Imagine how these marks might be used in your artwork.

The flat brush produces very geometrical and angular shapes with choppier, thin lines. The round brush creates smooth, curvy shapes with an overall sense of looseness. The rigger brush is perfect for forming long, continuous lines and can also be used for texture by applying pressure on the full body of the brush.

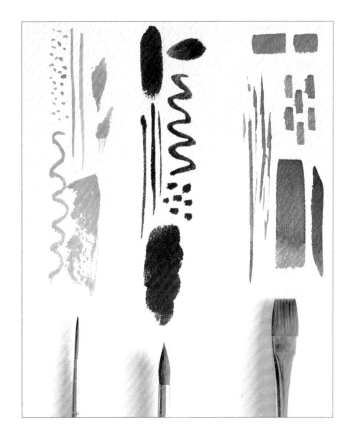

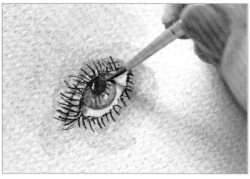

SPOTTER

Use spotters and other small brushes for detail work on paintings both large and small. Since the bristles are short, these tips don't flex easily. That stiffness is great for making small, precise lines.

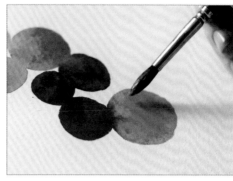

ROUND

Round brushes are so versatile. You can paint anything, from loose backgrounds to lines and details to flowers, buildings, and shapes.

FLAT WASH

Use flat wash brushes for covering large areas with paint. This is a great brush to use when painting the sky or laying down a base color over a large area.

RIGGER

The rigger brush is perfect for long, smooth lines. The long bristles drag with looseness, making it perfect for stems, poles, string, lines, and grass.

MOP

The mop brush has loose bristles that make it easy to paint free-flowing botanicals and greenery while also maintaining a sharp point for fine lines.

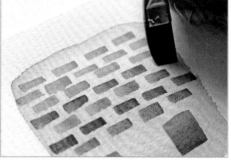

FLAT

The flat brush is perfect for creating hard lines and geometric shapes. It is a great tool for painting doors, windows, and bricks.

LETTERS

The basic brushstroke principles also apply to watercolor lettering. You can use the body of the brush as well as the tip and will utilize pressure in the brushstrokes. Creating letters and phrases with watercolor gives the lettering character and texture.

Water brushes are helpful when creating watercolor letters. This is a useful tool because it has a super-pointed tip that's perfect for fine lines but can also be pressed down for thicker brushstrokes.

upstrokes **downstrokes**

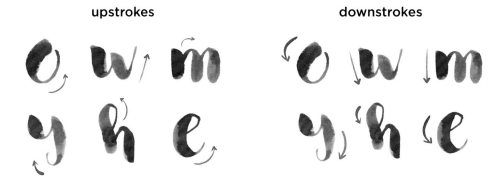

In lettering there are upstrokes and downstrokes. Downstrokes are thick, and upstrokes are thin. You can use what you've learned about brushstrokes to explore creating downstrokes and upstrokes in the letters.

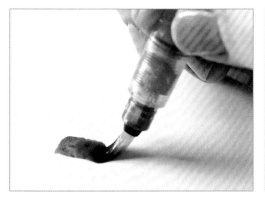

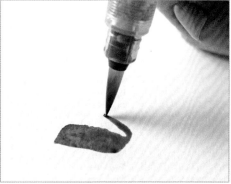

Press down on the full body of the bristles to create thick lines. These are the downstrokes of the letters.

Use the tip of the bristles for thin lines. These are the upstrokes of the letters.

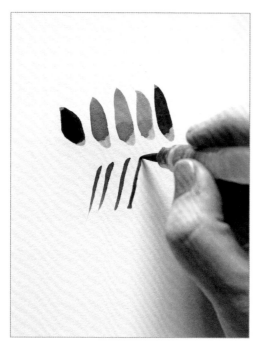
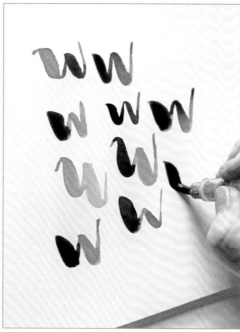

Practice making thick downstrokes with the body of the brush and light upstrokes with the tip. Then try putting them together by making a continuous, smooth transition from downstroke to upstroke to downstroke again. The letter "W" is perfect for practicing this exercise.

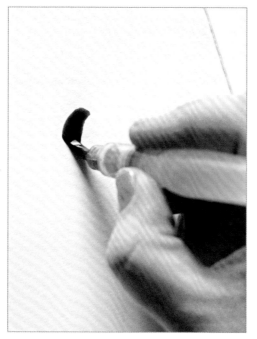
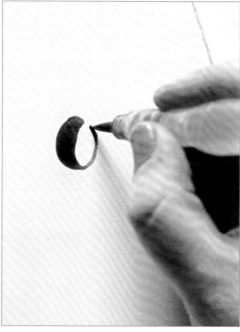

Next practice curvy letters like "O." As you reach the bottom of the thick downstroke, transition to a thin upstroke on your way back to complete the letter.

There are many different lettering styles to explore while creating watercolor letters. Paper choice also plays a part in the look of your lettering. Rough, cold-pressed paper yields a very textured look. Smooth, hot-pressed paper yields a smooth, clean look. Both styles are great and work well for a variety of projects.

"Love" and "dance" below are examples of lettering on rough, cold-pressed watercolor paper.

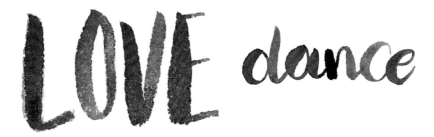

The words below are examples of lettering on smooth, hot-pressed watercolor paper.

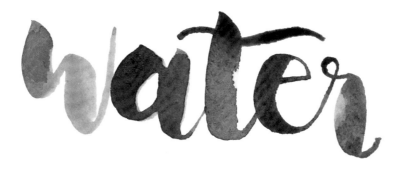

Practice painting the word "water" using a cursive font on smooth, hot-pressed watercolor paper. If you like, you can sketch out the lettering in pencil before painting. Be mindful of whether you are painting an upstroke or downstroke, and adjust your pressure accordingly.

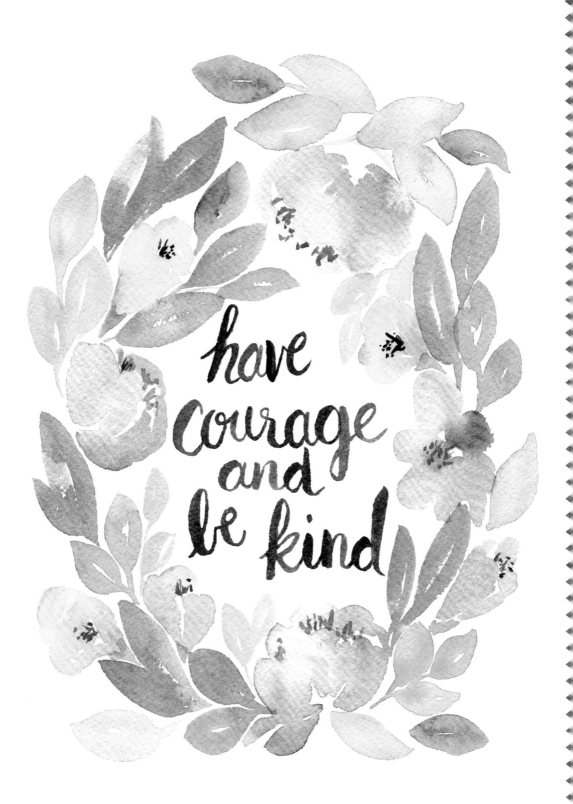

have courage and be kind

SHAPES

Circles & Ovals

Circles and ovals seem basic, but they can be tricky to master. You might find it easiest to paint the outline first, and then fill it in with a round brush.

With a little practice, you'll find that you can paint near-perfect circles.

Circles and ovals are found everywhere in patterns and nature. Having a basic knowledge of this shape will give you the foundation needed to paint them in real-life pieces.

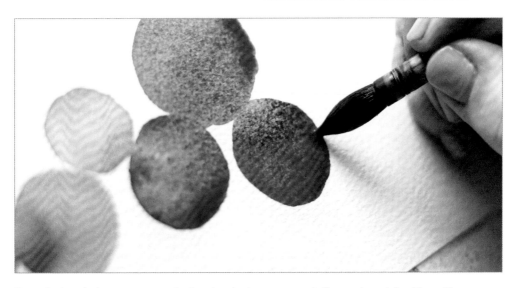

Try painting circles to warm up before beginning a new painting or to get familiar with a new paintbrush.

Triangles & Diamonds

Triangles and diamonds may be more angular than circles, but they are also easier to paint if you draw the outline of the shape first and then fill it in.

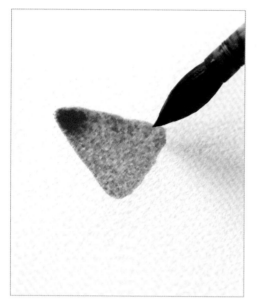

Use a round brush to paint triangles and diamonds.

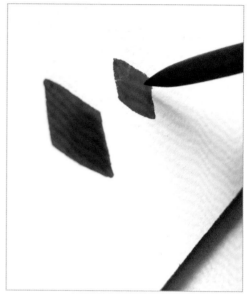

Triangles and diamonds are common shapes in geometric patterns and in more structured objects, such as buildings.

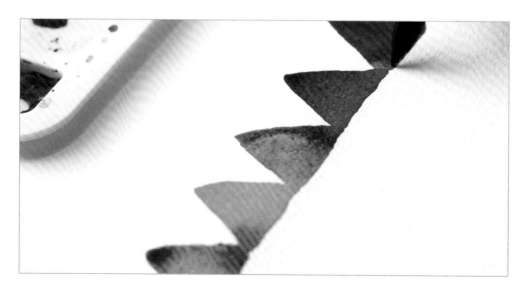

Paint triangles to practice painting straight, crisp lines with your round brushes.

Squares & Rectangles

It's easy to form squares and rectangles with a flat brush. Short strokes make squares, and longer strokes make rectangles. You can also use a round brush to draw the outline of the shape and fill it in.

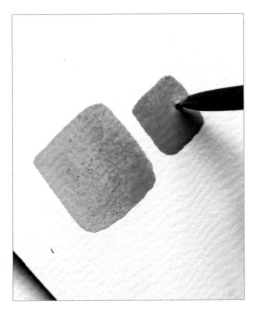

Using a round brush will produce softer corners.

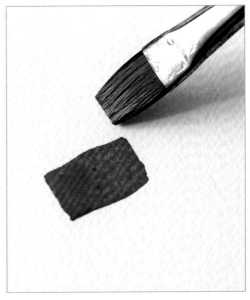

A flat brush will produce sharper corners.

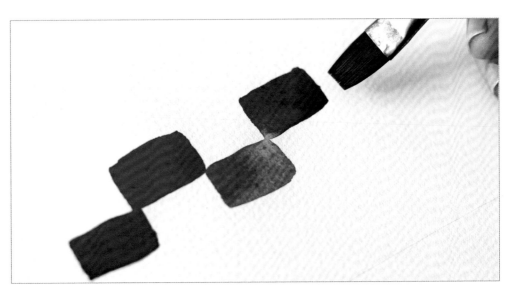

Squares and rectangles are very uniform. You can spot these geometric shapes in all kinds of structures, buildings, and even in nature.

Other Shapes

Other shapes, such as hearts, stars, and abstract shapes, are fun to paint—and they are open-ended for unique approaches and interpretation.

Paint hearts by pressing down on a round brush to create each arch.

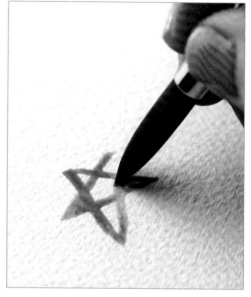

Stars are hard to form freehand, so I suggest creating a crisscross star and filling it in for a more uniform look.

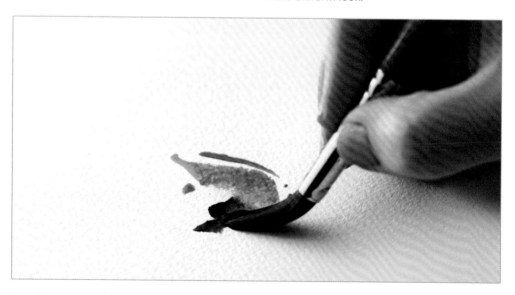

Anything goes when painting abstract shapes. Dots, lines, ovals, drops—whatever inspires you to create. Although abstract can be seen as "random," a lot of thought should go into the placement and flow of each shape.

Allover Patterns

To take your skills to the next level, try creating some allover patterns using all the different shapes. You can combine shapes for a fun mixed pattern or stick to one or two shapes for a more consistent look.

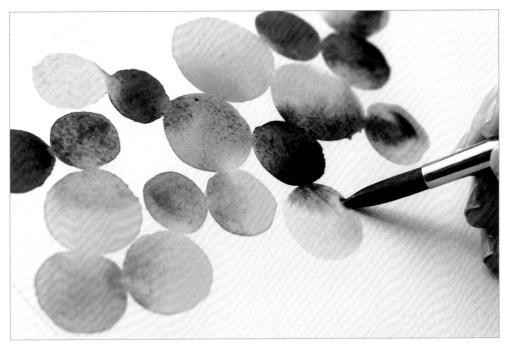

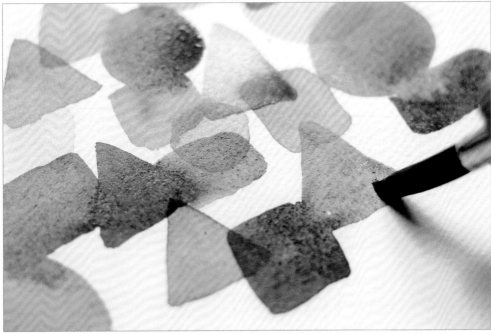

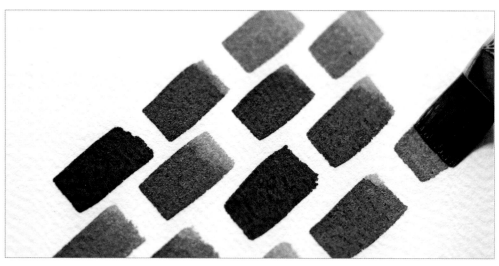

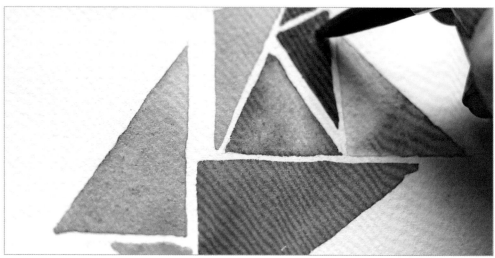

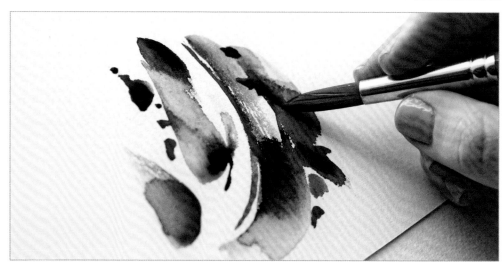

GET CREATIVE:

RESISTS

Resist techniques are fun for blocking or manipulating paint. You can use masking fluid, white crayon, salt, alcohol, or tape to preserve areas of the paper as you paint.

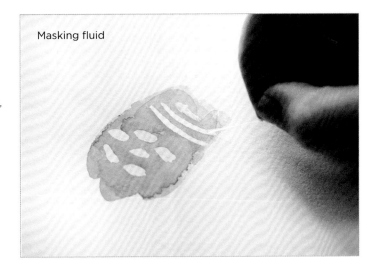

Masking fluid

Assignment

1. To use masking fluid (also called "liquid frisket"), simply apply it to an area you want to keep free of paint. Let it dry, and then you can paint right over it. Once the paint is dry, you can gently pull or rub away the masking fluid, revealing the white paper beneath.

2. Now try using masking tape. Simply place a strip of tape on your paper and paint over it. Allow the paint to dry completely before gently pulling the tape off at an angle so you don't tear the paper.

3. Play around with how salt reacts with wet paint. Apply a wash of paint in any color. Sprinkle salt over the wet paint, and let it dry. Once dry, brush away the salt with your hand to reveal the unique texture.

4. Try using alcohol to create interesting feathery shapes in a watercolor wash. Apply a wash of paint in any color to paper. Use a paintbrush to drop in rubbing alcohol while the paint is still wet.

Masking fluid is tough on your brush bristles. Use an older or less expensive brush exclusively for masking fluid. Save your nice brushes for painting!

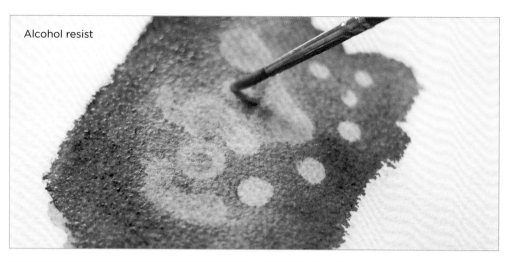

Alcohol resist

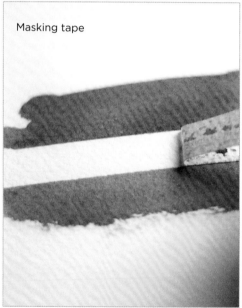

Masking tape

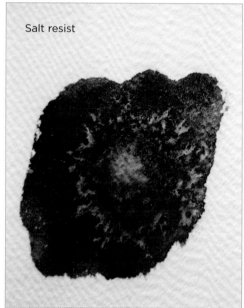

Salt resist

TRY THIS!

Water and wax don't mix. When you draw with crayon on paper first, the paint will bead up on the wax. Simply draw on watercolor paper with a white crayon (or other colors if you like) and apply paint over the wax. As you paint, you'll see the shapes or design you drew in crayon remain free of paint.

BOTANICALS

PEONIES

Remember that a flower is like a cone, and all petals point toward the center. Use the body of the paintbrush to make the curvy tops of the petals and the tip of the brush to bring the petal to a point. Use light and dark values to create variety and depth, and add upper layers of petals with a lighter wash. You can create bleeding by adding the yellow center while the pink paint is still wet for a unique look, or you can allow the petals to dry before adding the center.

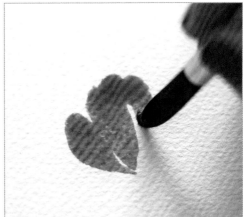
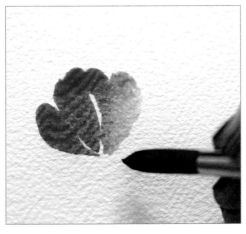
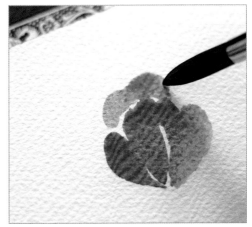

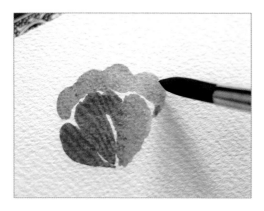
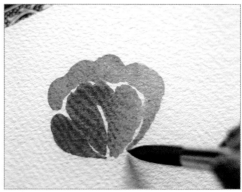

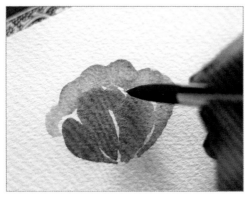
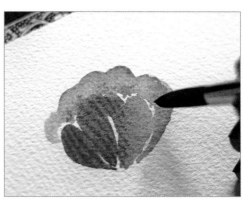

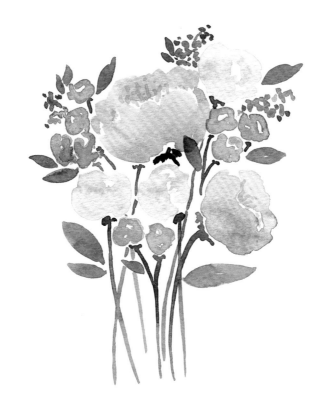

ROSES

When painting a rose, start with a small center circle and three lines around it. Create curved shapes that are more voluminous on one side. Coordinate the petals so the layers adjacent to one other don't match up. Continue adding layers until the flower is the size you want.

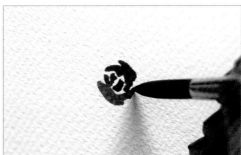

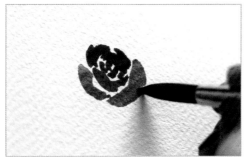

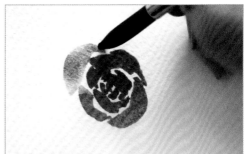

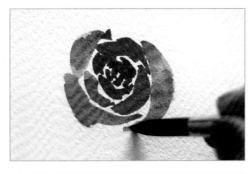

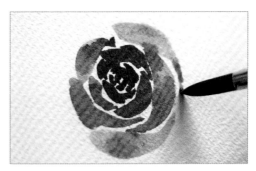

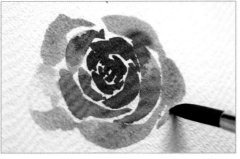

TIP

As you move out from the center, use less pigment and more water to create depth.

OPEN FLOWERS

For open flowers, such as cosmos and pansies, paint one petal at a time until you reach the desired shape. Mix up the sizes of the petals for a lifelike look, and leave some white space in between for definition and to create the illusion of separation. Add more pigment to create interest and diversity in the petal color.

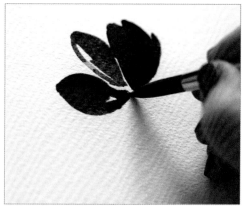

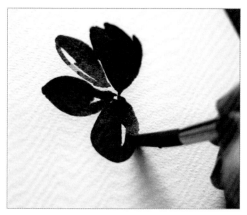

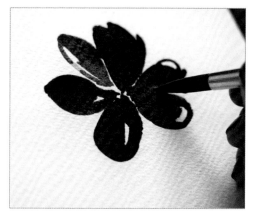

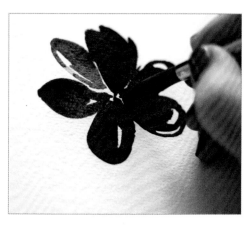

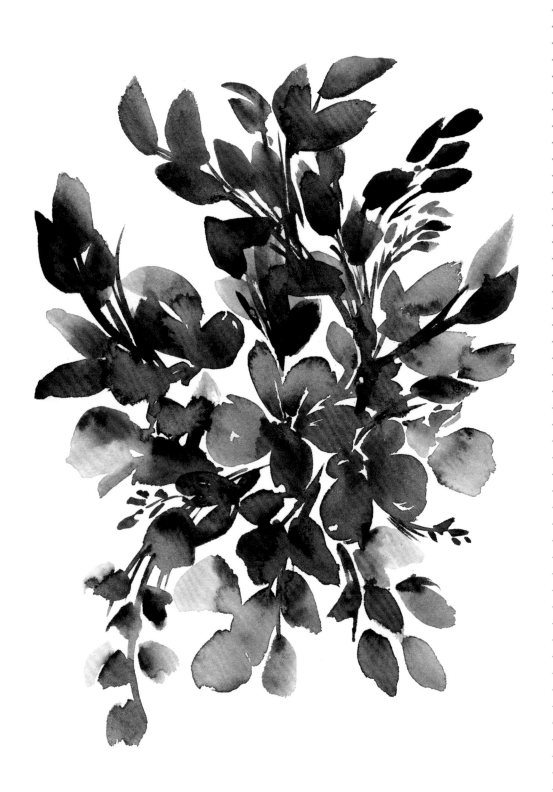

CLOSED FLOWERS

Some flowers, such as tulips, are more naturally closed, and the centers are not visible from the side. Paint the petals straight up and slightly curved inward. Create separation of petals with white space or lighter and darker paint values.

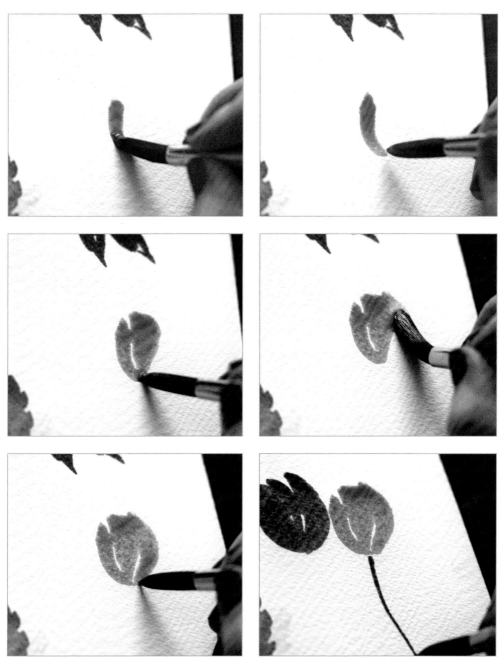

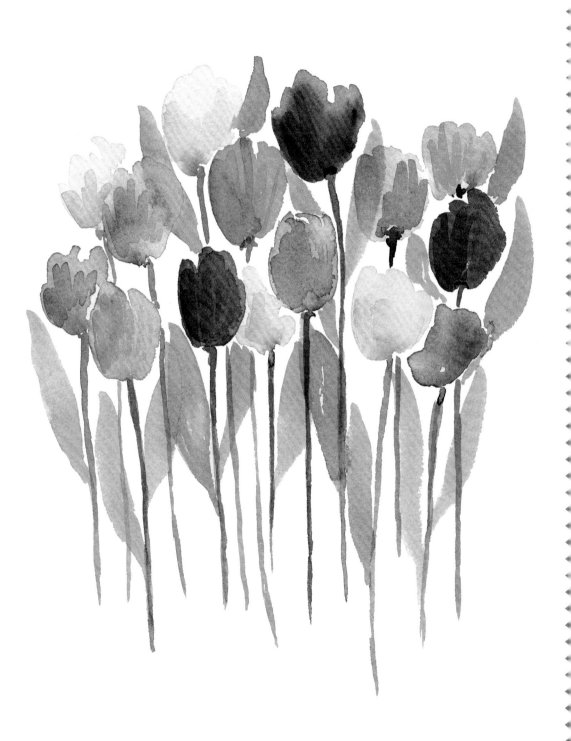

GREENERY

Although not as obviously varied as the vast array of colorful flowers, greenery can be just as beautiful and comes in many shapes, sizes, and shades of greens. Here are several easy and simple ways to paint lovely bits of greenery that you can add to your botanical paintings to create lush, full floral artwork.

Leaf 1

Using the body of the brush, push upward to create the entire leaf.

When you have reached the desired length of the leaf, use lighter pressure to transition to the tip of the brush to create the leaf tip.

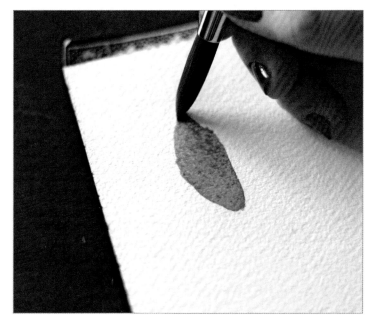

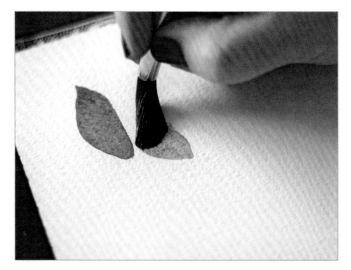

Leaf 2

Imagining a line in the center, create a "C" shape with the body of the brush on one side.

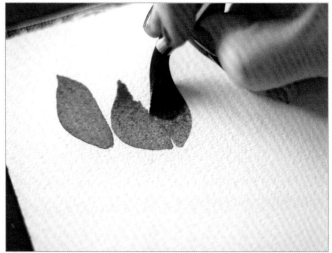

Repeat on the other side.

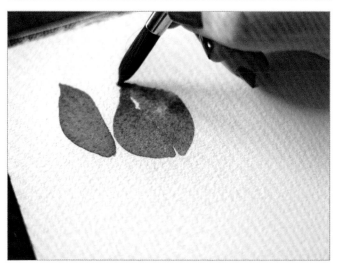

Use light pressure at the top to form the tip of the leaf.

Leaf 3

Use the body of the brush to create volume.

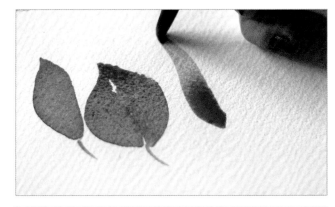

Paint long strokes for long leaves. Leaving the middle of the leaf white creates the illusion of a center line and defines the leaf.

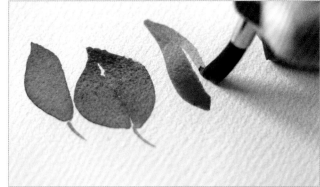

Leaf 4

Use the body of the brush and a long stroke to create a slender, elongated leaf.

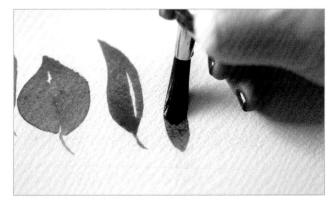

Remember to decrease the pressure on the brush as you near the end of the leaf to taper the stroke.

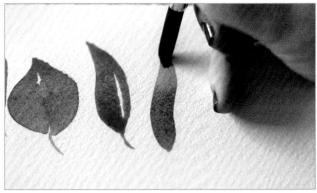

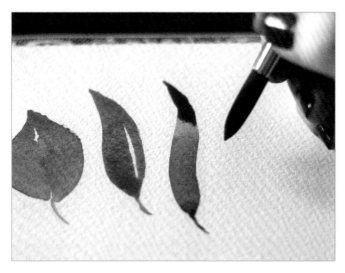

To create depth on leaves with no center line, apply darker color at the top or bottom—or both! This can suggest shadow as well as new growth.

Leaf 5

Use the tip of the brush to paint a leaf with jagged or rough edges.

Leaf 6

Use the body of the brush to create a smooth, round leaf.

Foliage 1

For short-leaved foliage, create the stem first. Then use the body of the brush to paint short leaves growing from smaller stems.

Foliage 2

Follow the same process to paint long-leaved foliage. Create the stem first, and then use the body of the brush to paint voluminous leaves growing from smaller stems.

Foliage 3

For needled foliage, use light pressure to make quick strokes outward from the stem with the brush tip.

Foliage 4

Make long strokes for longer needles. For rounded needle tips, start away from the center and bring the point of the brush to the stem.

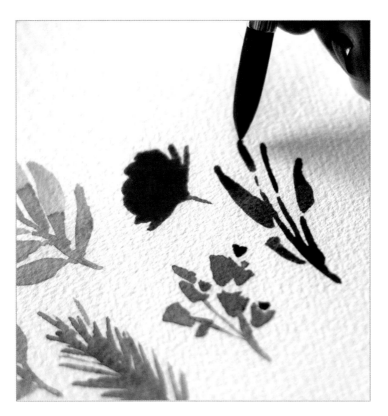

Foliage 5

Stems and random shapes perfectly capture the look of scattered greens, such as weeds.

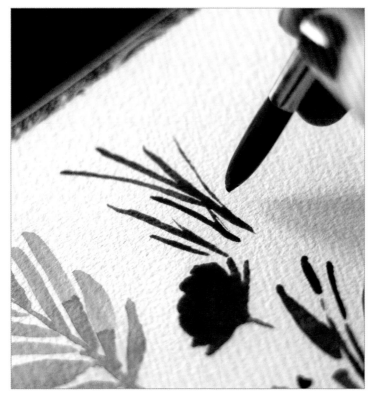

Foliage 6

When painting grass, create long, thin lines while altering the direction in which they point.

GET CREATIVE:
PAINTED CACTUS GARDEN

Painting cacti is a fun way to stretch your creativity. Cacti come in all shapes, sizes, colors, and textures. We usually think of cacti as green, but many of these desert-dwelling plants feature beautiful brightly colored blooms. Cacti can be tall and skinny, round and squat, prickly and spiky, or even fuzzy!

Assignment

1. Practice painting several types of cacti. You can use reference images to paint specific species if you like, or get creative and paint something abstract and unique.

2. Have fun putting them together to create a cute cactus garden or desert scene.

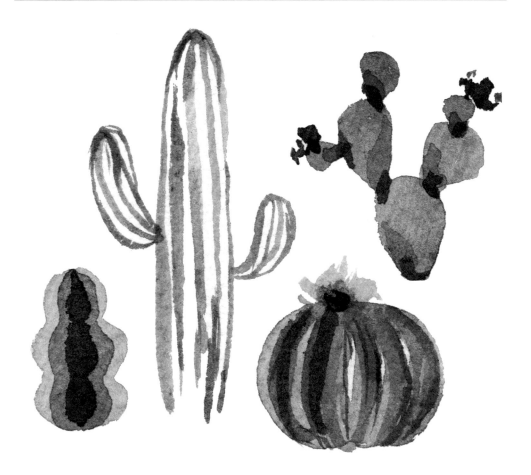

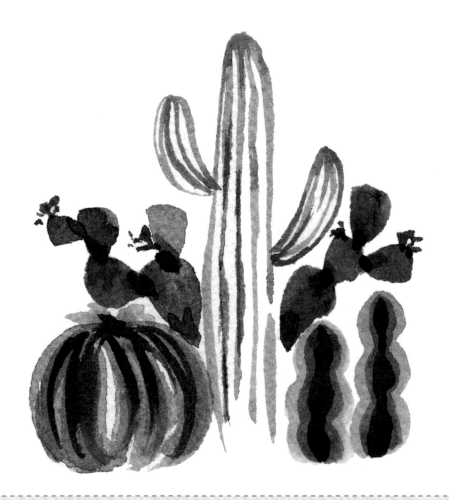

Cacti have lots of different colors, layers, and patterns. Make sure to let each layer dry properly so you can add new layers without blending.

Long lines with white space in between perfectly capture the ridges on a saguaro cactus.

GET CREATIVE:
WREATHS

Wreaths are another type of pattern. If you apply the same steps you learned for painting flowers and leaves, it will be easy to create a beautiful, uniform, and cohesive wreath.

Assignment

1. Start by sketching a large circle so you have an outline for where to place the florals and greenery. Then begin by painting the biggest shape first—typically the "main event" floral and its corresponding leaves.

2. Next add a contrasting smaller floral next to the big one, and give it some small or grassy-looking leaves. Then start adding darker parts that allow for contrast, like dark twigs or small leaves.

3. Finish by layering more leaves in a different hue over existing leaves, and revisit the florals to add detail.

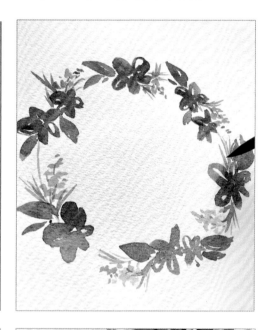

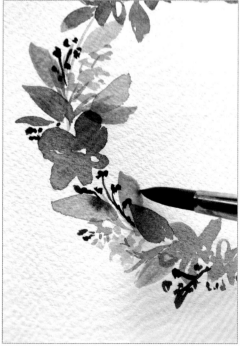

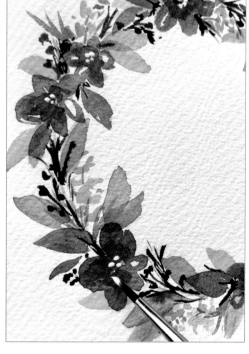

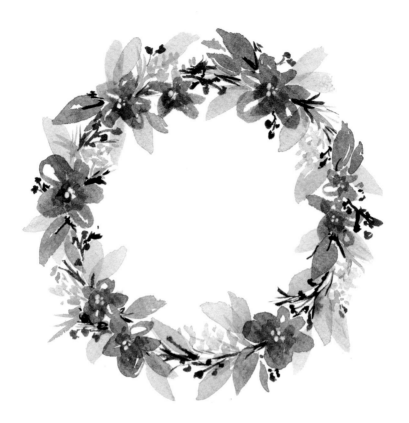

Consider the direction in which you want the leaves and flowers to go so everything stays consistent. If you go for a wilder look, with leaves going in different directions, make sure you're consistent with this look throughout the wreath or it won't look right.

EVERYDAY OBJECTS

LIVING ROOM

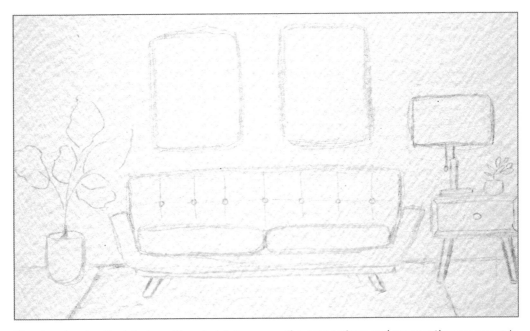

Start by planning the interior with a sketch to ensure the proportions and perspective are accurate.

Begin painting the objects in the room with a flat base of color. Start with the blue couch. Paint a light gray wall before moving on to the other elements.

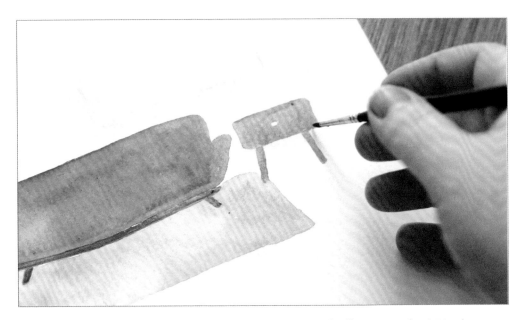

Continue painting the other objects in the room. As you work, allow areas of paint to dry before painting other parts that touch to avoid blending colors. For example, let the paint on the couch dry before painting the wood frame and legs. For the rug, blend multiple colors together for a vintage look.

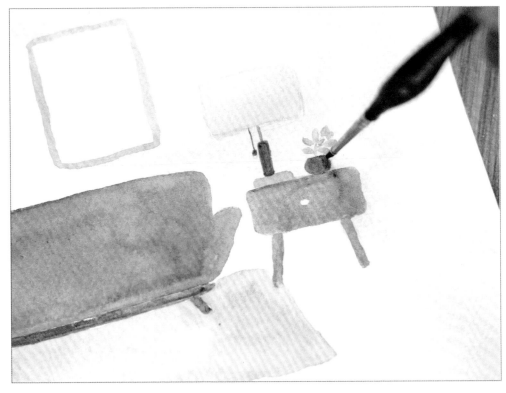

Begin painting a base color on all the smaller objects in the room, such as the lamp. Then add plants and greenery.

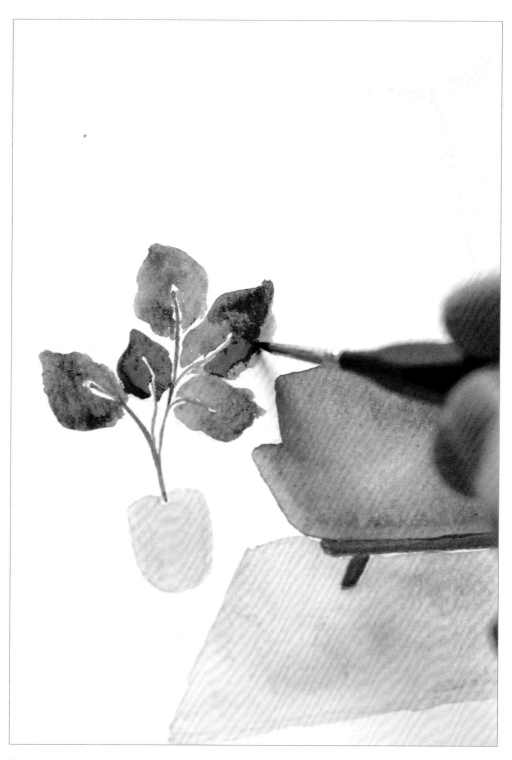

You can refer to the section on painting botanicals for tips on painting the greenery and flowers. (See pages 52–69)

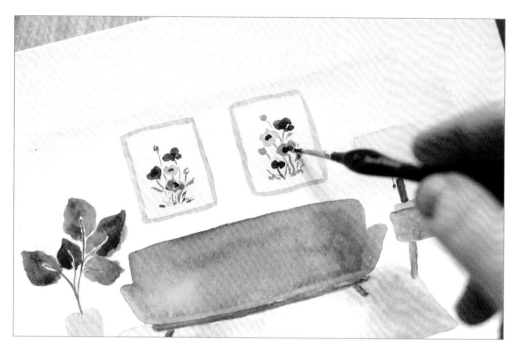

Create artwork for the wall.

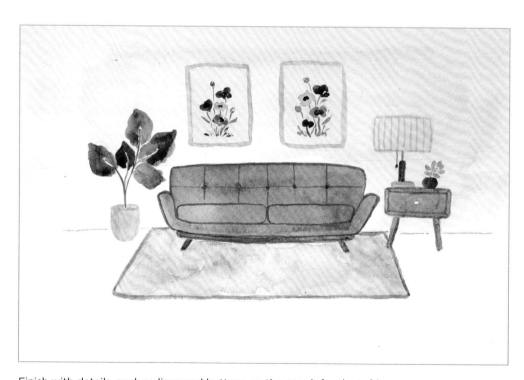

Finish with details, such as lines and buttons on the couch for the tufting.

COZY COTTAGE

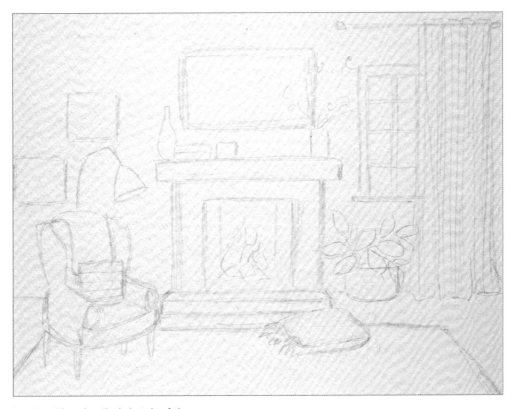

Begin with a detailed sketch of the room.

Paint a base layer of color on the chair, and let it dry.

Paint the curtains with a light base color, leaving white space for highlights and definition.

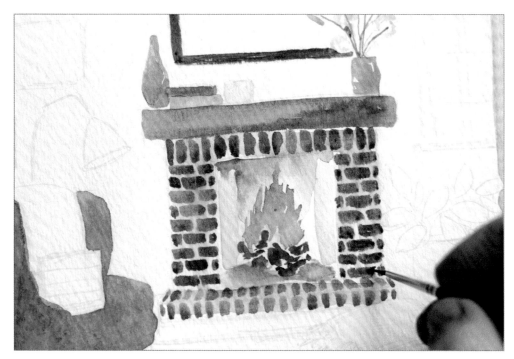

Add color to the mantle and smaller objects on top. Then paint the bricks on the fireplace. To create the natural look of brick, vary the paint color slightly and make some strokes shorter on the edges to indicate smaller bricks. Paint the fire inside.

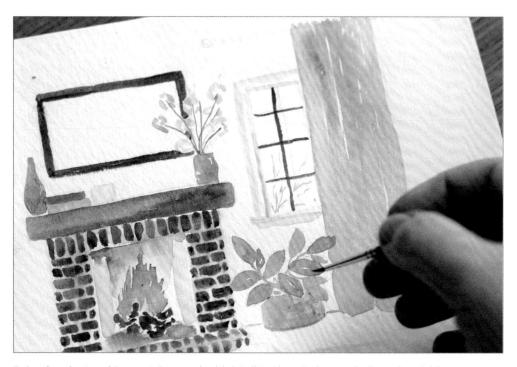

Paint the plant and its container, and add detail to the window and a branch outside.

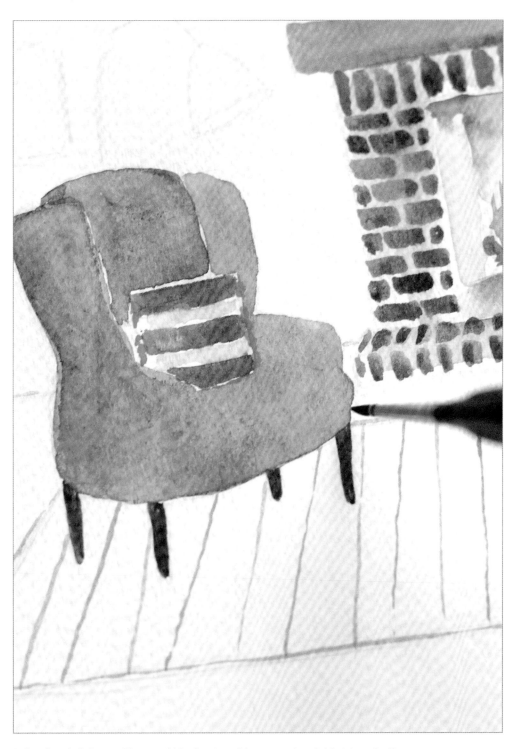

Paint the chair legs, pillow, and blanket to add more color. Add stripes to the rug.

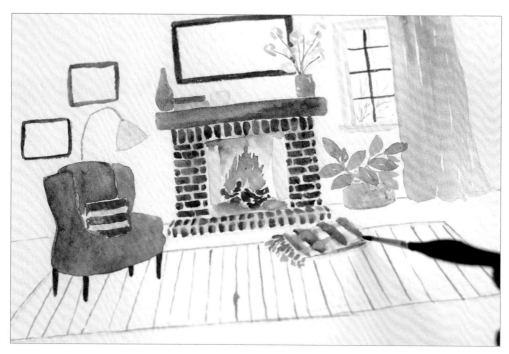

Paint the blanket on the floor, the lamp, and the frames on the wall.

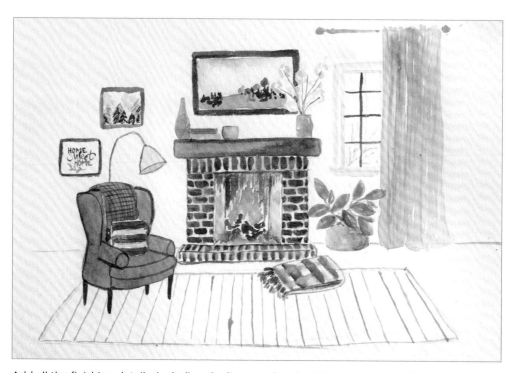

Add all the finishing details, including the lines on the plaid blanket, a dark outline on the chair and floor lamp, and some darker strokes in the curtain and plant leaves to add dimension. Don't forget to add artwork to the frames.

GET CREATIVE:

SUBJECTS ALL AROUND

When you're not sure what to paint, you can look for inspiration all around you—sounds, colors, textures, mood, feelings, and so on. This is why it's important to paint and create in a space that inspires you, wherever that may be. Why not try painting the room you're in and letting the colors and textures inspire you?

Assignment

1. Find a room or place you love. Sit in an area looking from the perspective you want to paint. A picture will work too if you can't be in the place you'd like to paint!

2. Get painting! Remember that a painting doesn't have to be an exact copy of your reference. Being inspired by the mood, colors, and feelings means you may be compelled to change things, and that's perfectly OK! In fact, it's one of the best things about an exercise like this.

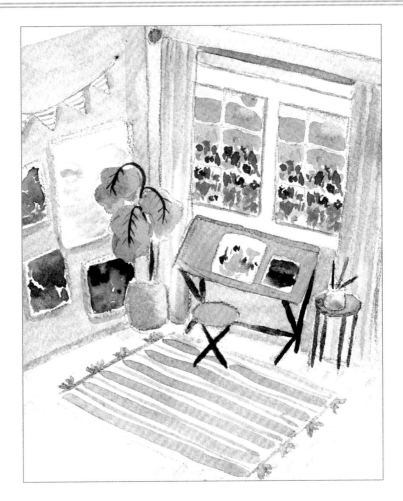

ITEMS AROUND YOU

Go around your home and collect everyday objects to paint!

Assignment

1. Grab a few ordinary, everyday items ranging in interest and size from around your space. More ordinary objects will better stretch your creativity and ability to paint anything.

2. Focus on each item's shape, texture, and color. Is the object translucent or opaque? What are its basic shapes? Are there any unique parts? Is it smooth, fuzzy, or prickly?

TRY THIS!

When you're painting an object that is *flat*, or one color, add different variations of the same hue to create shadows and texture. You can even add a totally random color for contrast and interest.

AT YOUR JOB

Every profession or hobby requires tools to accomplish various tasks. For watercolor painting, it's water, paint, paper, and brushes. For an accountant, it may be a computer, spreadsheets, pens, charts, and a calculator.

Assignment

1. Think about the tools of the trade that you use for work. Maybe you're a lawyer, a stay-at-home mom, a student, a social worker, or a cashier. Try to think outside the box about the things you use every day to get your work done.

2. Choose several tools to illustrate. Try to fill the page if you can!

TRY THiS!

This exercise is a fun way to paint things you have never painted before! Choose a profession, and then paint the tools of that trade. In this example, you'll see the tools used by a dental hygienist: scrubs, mask, gloves, mirror, scaler, explorer/probe, suction, air/water, toothpaste, floss, and a toothbrush.

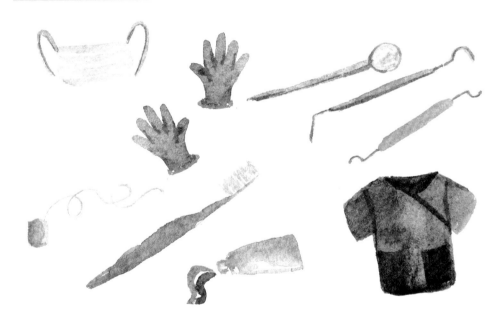

When you're painting objects that are one color, they can turn out very flat. Don't forget to go back over them once dry with a darker color or a more saturated version of the same color to add details.

YOUR TO-DO LIST

Everyone has a to-do list—and a fun way to get creative, think outside the box, and jazz up your to-do list is to paint it. This colorful approach to listing all the things you need to do is bound to make checking them off even more fun!

Assignment

1. Write out your list for the day, the week, or even for a specific project. Be as specific or as general as you want for each task.

2. Then have fun painting your list! You could paint yourself doing each thing, or you could paint an object that helps you do that specific task.

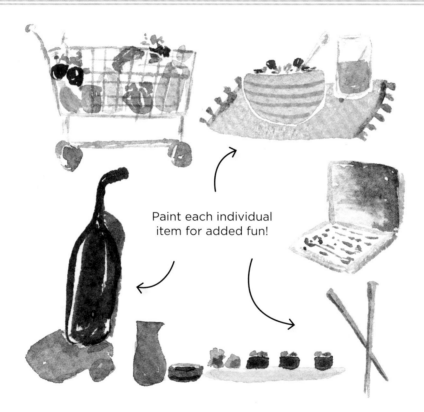

Paint each individual item for added fun!

TRY THIS!

If you're a visual person or someone in your house is, make your own illustrated cards that represent several different "to-do" items. Each day, you can switch them up based on your list.

ILLUSTRATED FOOD JOURNAL

Try writing down what you eat in a day to see an overall view of what you put in your body. Then paint what you ate! It's a great visual of the colorful foods you ate that day.

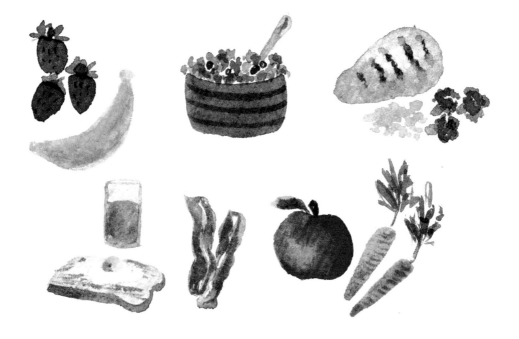

It's enjoyable—and sometimes enlightening—to see all the food you consumed in an illustration. It may even inspire you to eat healthy foods, knowing you'll be painting them at the end of the day!

YOUR PASSIONS

Everyone has a passion or something that keeps getting them up in the morning and working toward goals—something that brings genuine happiness. Your passion might be your children, your home, your job, a political cause, a social cause, your community, a hobby, or traveling. Many people have multiple passions!

Assignment

1. Pick something you are very passionate about and make a list of things that come to mind when you think about this passion.

2. Paint each item on your list in either a direct or interpreted way, or make one art piece that altogether symbolizes your passion. Let your passion shine through in your painting!

You can use technology to scan your paintings into your computer and move elements around in a photo-editing software program to create exactly the illustration you had in mind.

ANiMALS & PEOPLE

FOX

Apply a light wash of orange watercolor paint evenly on dry paper, leaving the white parts of the fur unpainted. While the paint is wet, drop in bright yellow, red, and orange to create interest and variety.

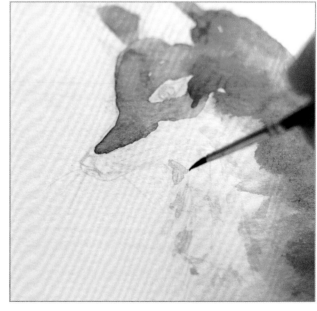

Paint fur details on the white areas with light gray paint to add depth. Don't overdo it—you only to need to create the impression of fur, not paint each individual hair.

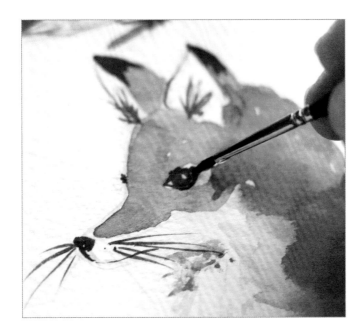

Use black paint for the nose, mouth, eyes, whiskers, and inner ear hair detail. Paint the tips of the ears black. Dilute black paint with water to lighten, and add a shadow under the chin to add dimension, as well as a few strokes in the chest fur.

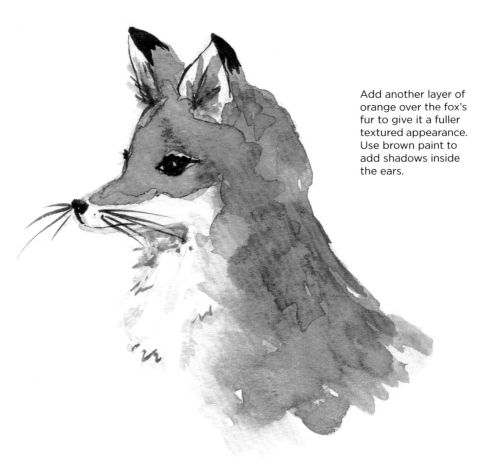

Add another layer of orange over the fox's fur to give it a fuller textured appearance. Use brown paint to add shadows inside the ears.

SQUIRREL

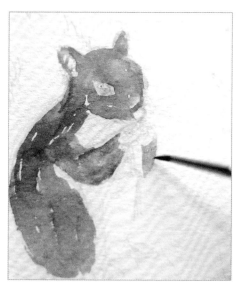

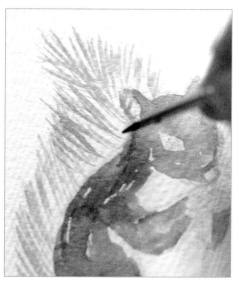

Apply a light brown wash of watercolor across the body, leaving the white of the paper for the white fur. Leave a few small unpainted areas in the brown fur for highlights.

Squirrel tails are darker at the center and lighter at the edges—an important observation, since you need to start with the lighter color first. Use light, sweeping strokes, going out from the body of the squirrel.

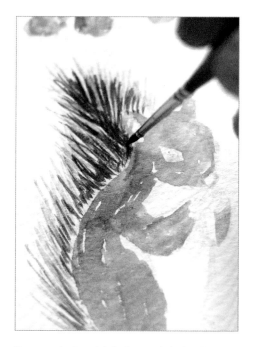

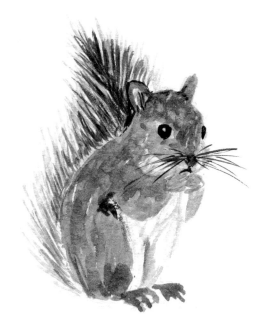

Progressively add darker and darker browns until you are satisfied with the darkest hue. Remember that you can't add back white or lighter tones, so add dark colors sparingly.

Use black to paint the nose, mouth, and whiskers as well as the eyes and a few dark accents. Paint gray details and shadows on the white fur. For added texture, apply another layer of color over the brown fur.

RABBIT

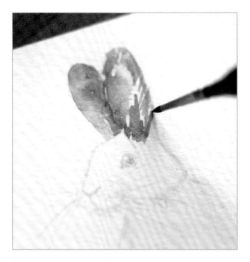

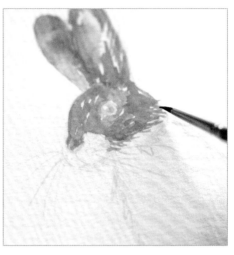

Start by painting the rabbit's ears and working down the body. The fur is very textured; use patchy, thin strokes.

Rabbit fur has a lot of dimension and color. Use different shades of gray and brown to achieve the look, leaving any white areas unpainted. Paint the thin fur strokes in the direction of growth.

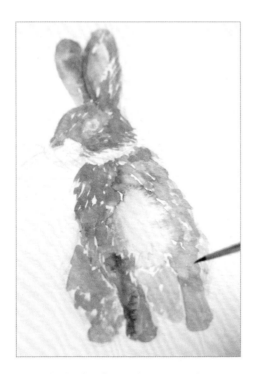

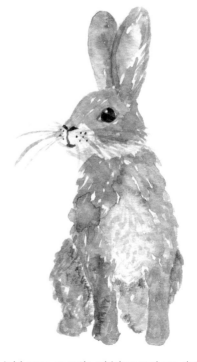

Paint the body of the rabbit in patchy downward strokes, leaving white space for highlights and definition. The center of the body is light but not white. Use very watered-down paint.

Add nose, mouth, whisker, and eye details. Use light gray to define the white and light areas of fur.

CHICKEN

Start by painting the red areas on the chicken's head. Leave small areas of white for highlights. Use a small detail brush to paint small strokes in the direction of the feathers. This breed has long black-and-white neck feathers. Leave lots of white space for the white feathers.

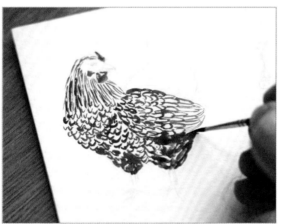

Paint small scallop shapes on the breast and wings. Define the wings from the body by making the feathers slightly longer and going in a linear direction. Paint the leg feathers darker and closer together, showing less white. Use long, tapering strokes to paint the feathers at the tip of the wing.

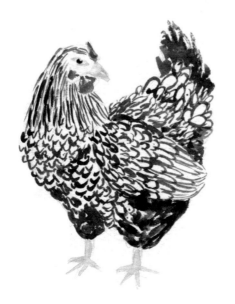

Finish off the feathers along the tail, fanning them out. Add details to the feet, beak, and eyes.

PIG

Start by painting an initial light layer of pink watercolor over the pig's body.

Add a more concentrated pink shade to the ears and nose to create dimension. Add another layer of light pink to the body for texture and depth.

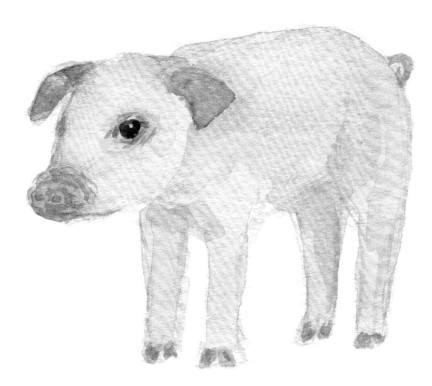

Add detail to the nose, eye, and hoofs. Create wrinkle lines around the eyes and nose with a slightly darker pink. Just a few lines will do the trick!

DOG

First paint tiny eyebrows and a touch of brown on the sides of the face. Then paint the black body, applying the paint unevenly and in layers to mimic the texture of dog fur. Leave white areas of fur unpainted.

Bring black into the chest to define the edges of the white fur, making light, sweeping brushstrokes from the black paint into the chest.

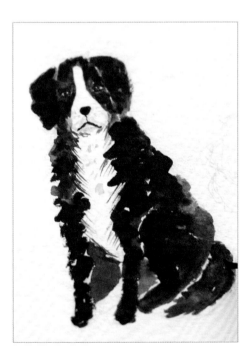

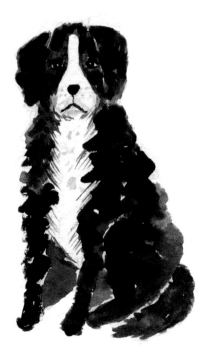

Add nose, mouth, and eye details. Use light gray paint to define the white fur at the mouth and chest.

Be sure to use a lighter wash of black to paint the dog's rear right leg, which is further back than the other three legs. Darker paint colors appear to come "forward" on the page, while lighter colors appear to "recede." This is an important concept to understand about suggesting distance.

CAT

Paint patches of orange watercolor to start the cat's fur. This cat also has patches of white fur, so keep a lot of white space for contrast.

Add more defined patches and stripes by adding a darker orange shade. Remember that you can't add white and light colors back in, so be light-handed when adding darker colors.

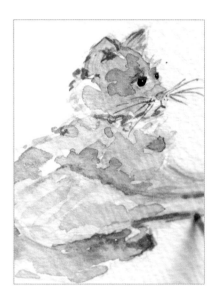

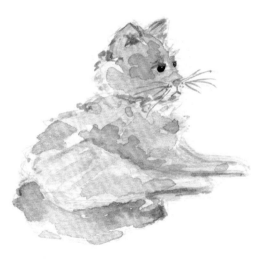

Add nose, mouth, whiskers, and eye details. Apply darker brown fur to define the legs, head, ears, and tail. Then use light gray paint to define areas of the white fur.

Notice how this illustration of a cat is truly nothing more than some simple brushstrokes and variation in color value to create depth. You don't need to consider yourself an artist to work with watercolor paints. Anyone can create simple paintings!

BEETLE

Start by painting the beetle with an even shade of blue-green paint, leaving white highlights.

Add black to the upper sections of the beetle, bringing some of it down into the reflection on the shell. Paint thin, uneven lines on the shell to define the pattern, following the natural curve of the shell.

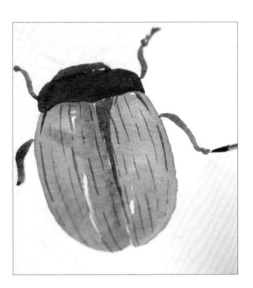

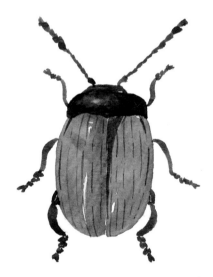

Paint the legs. Using uneven strokes on the end sections creates texture without adding too much intricate detail.

When painting the antennae, use quick strokes for a textured look. Start with small strokes, making them progressively larger toward the tip.

BUTTERFLY

Start with the base layer of watercolor paint. Use different shades of orange and yellow for interest.

While the wings dry, paint the leaves, flowers, or branch. You should paint this early on so it can dry before you paint the butterfly's body and legs.

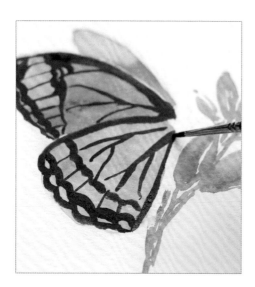

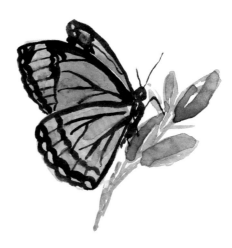

Add line detail on the wings with black paint, using light pressure for the thin strokes and heavy pressure for the thick strokes.

Paint the body, legs, and antennae. Leave white space on the body for highlights.

ELEPHANT

Start by painting a light gray color across the elephant's ear, leaving white space in the appropriate places, such as inside the ear, for highlights.

Drop in different shades of gray and blue while the paint is wet, working somewhat quickly so that an area doesn't dry before you can paint the whole of a section.

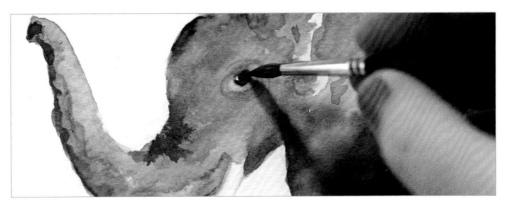

Add darker grays and blues for shadow and definition under the neck, the bottom of the trunk, and in wrinkled areas.

Add wrinkles on the trunk and around the eye and body. Don't overdo it with wrinkle lines—just a few will create the idea of wrinkly, textured skin. Add eye detail and shadowing under the neck and tusks.

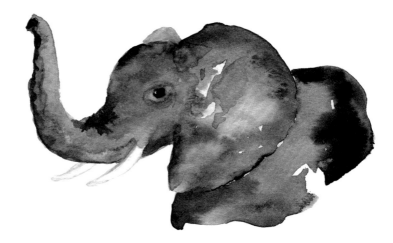

LION

Start by painting the face light orange. Don't forget to leave the lighter areas of fur unpainted. Bring the orange paint into the mane. Make light strokes from the face outward to look like fur.

Add the dark layers of fur using chocolate-brown paint. Make light strokes from just above the orange hairline growing outward. This makes it look like the orange hairs mix with the brown hairs where they meet. Leave white space for definition and highlights.

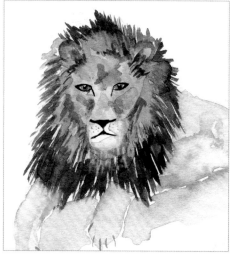

Drop in more orange paint in the mane, using a shade that is slightly darker than the face.

Paint the eyes, nose, and mouth. Define the ears and the hair detail around and inside them. Add light patches of brown for the texture on the lion's face and a darker brown to define the outline of the face against the mane.

GET CREATIVE:
ANIMAL STUDIES

The idea of painting animals can feel quite intimidating, but if you break your subject down into basic shapes, even the most seemingly complex animal becomes much more manageable. For instance, a rabbit's basic shapes are circles and ovals, while a cow's head is more angular, with squares and triangles.

Assignment

1. Choose an animal to paint, and sketch the basic shapes of the animal lightly. Then start to fill in the gaps between the shapes with more curved lines. This gives you a great base sketch for your painting.

2. Remember that different animals require different brushstrokes and techniques to create their unique hair, fur, or feathers: short, choppy brushstrokes for furry creatures; long strokes for a horse's mane; layered and irregular marks for leathery skin, and so on. Use your brush to your advantage!

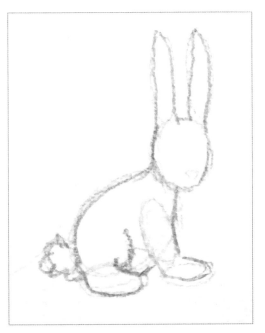

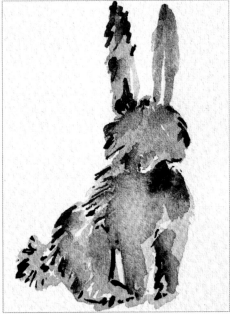

When painting animals, it is important to create dimension and add small details. To do this, start light and let the layers dry fully before adding the next wash of watercolor.

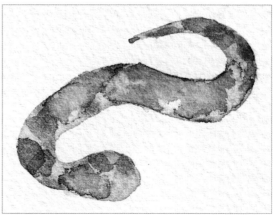

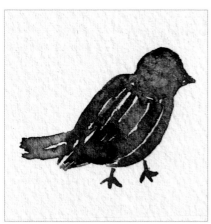

Use mark-making and other techniques to get creative with animal textures and patterns. For a snake, use hard edges and layering; for a rabbit, use short strokes and blending; and for a bird, use smooth edges with white space for definition.

HUMAN FACES

Painting portraits can be challenging, but it's possible to create whimsical faces that capture the essence of the person. Just like with animals, a few well-placed strokes and details go a long way. Take a peek at the examples below and follow the tips as you practice painting faces.

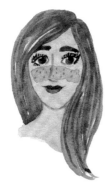

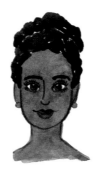

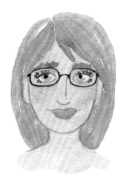

Mix pale skin colors with small amounts of yellow, red, and brown until you reach the right pigment—this face has a pink undertone.

Mix dark skin colors with brown, red, and green. The green helps balance the mix so that it isn't too red.

For thick, curly hair like this, leave sporadic areas of white space to define the curls.

To create a pale skin tone that has a golden undertone, combine yellow, red, and brown, but use more yellow.

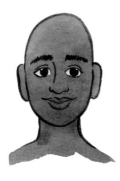

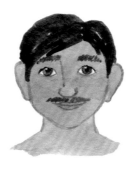

This dark skin color mix of brown, red, and green contains a bit more red to create the reddish undertone. For masculine figures, use very light color to paint the lips.

Like pale skin tones, light brown or tan skin is also a mix of yellow, red, and brown. Add small amounts of paint until you reach the right pigment. The yellow paint will help prevent the color from getting too dark.

To create a very pale skin color mix, combine yellow, red, and brown as usual, but make the mixture very watered down.

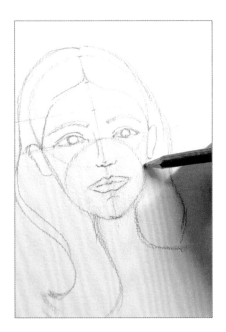

Choose a reference picture of a friend, yourself, or even someone in a magazine.

Work in pencil first to figure out the shapes and lines of the face. Rework it until it looks right—this foundation is important!

Once you're happy with the sketch, use watercolor to add color. Try to get your portrait to look as similar to the person as you can, but don't be afraid to add your own personal style and change things up. It doesn't have to be realistic.

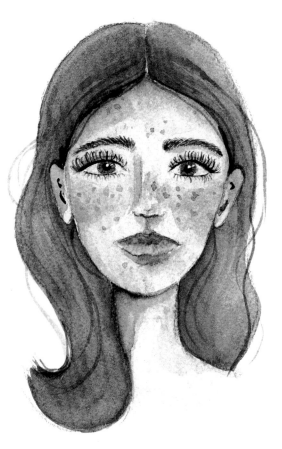

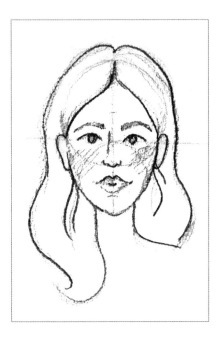

Skin, hair, eyes, and lips are all made of many different colors—and some may be unexpected. Don't be afraid to blend blues, purples, pinks, and yellows to add depth and realism to faces.

OUTDOOR SCENES

SUNSET

Paint the upper two-thirds of the paper with plain water. Then apply a highly concentrated area of bright yellow watercolor paint in the lower end of the wet section of paper. Apply reds and oranges at the top of and around the yellow paint, allowing the colors to blend together.

Add dark blues, blacks, and purples at and above the red and orange paint. Allow the colors to softly blend while still maintaining the red color.

Before the paper dries completely, lightly dab some of the paint away with a paper towel to create texture and movement in the night sky. If needed, you can apply diluted paint over the dabbed areas to bring back a little more color.

Allow the paint to dry completely. Then begin painting the horizon, using dark blue and black paints.

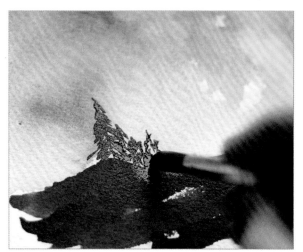

Begin to add mountains and trees against the colorful sky.

As you paint the trees, keep in mind that they should be more textured at the outer branches and very dense near the trunk. Paint the trees at different sizes to create depth.

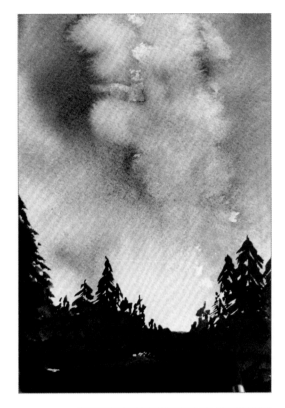

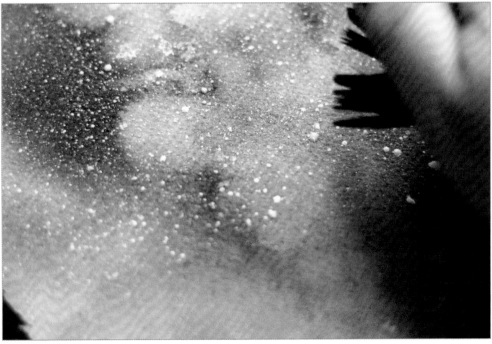

To create stars, dip a flat brush or toothbrush into white ink. Flick the ink onto the paper using your thumb. Be sure to cover the dark trees with paper to keep them free of white dots!

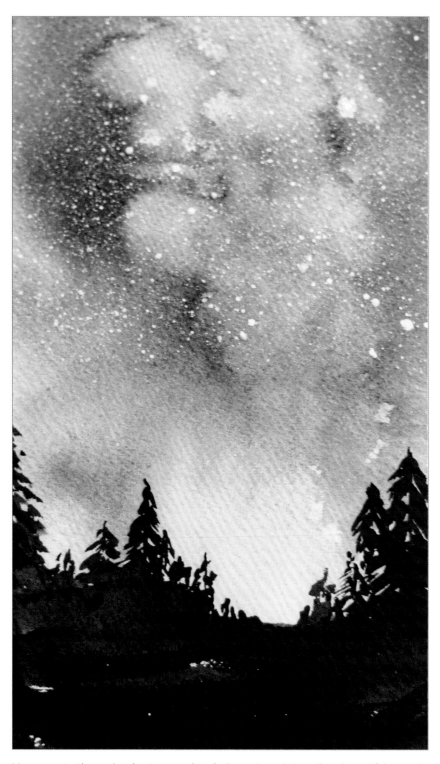

You can use these simple steps and techniques to paint endless beautiful sunset scenes. Try creating a glittering city skyline next!

LANDSCAPE

Landscapes can be done in so many different ways to achieve a beautiful painting, whether it's detailed and realistic or flowy and abstract. Using basic techniques to approach your landscape will help you nail the perfect balance every time, no matter what style you choose.

Start by making a light sketch of the scene. It doesn't have to be dark or exact, just something to help you keep your composition intact.

Use an allover wash on areas like mountains and oceans. Use different colors to add blending effects and textures. Let those areas dry, and then come back to add details, shadows, and other effects.

For areas like grass and trees, keep strokes really light and separate from one another. The white space will help differentiate between branches, leaves, and grass.

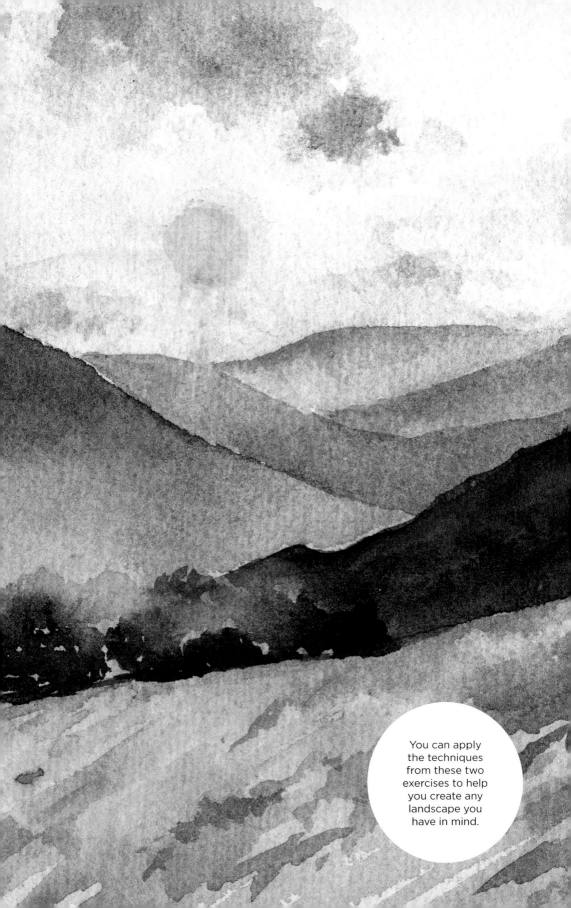

You can apply the techniques from these two exercises to help you create any landscape you have in mind.

OCEANSCAPE

Suggesting movement can be one of the trickiest things to do when painting. Luckily, with watercolor, so much of the movement happens with the paint. Letting the paint blend and move around your painting will work to your advantage as you paint a scene or an object in motion.

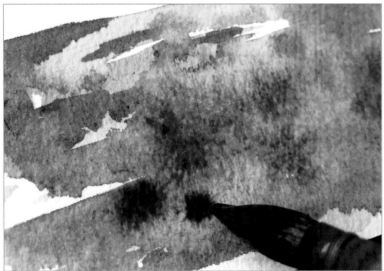

Remember that with watercolor, your lines can dry very crisp and hard. To prevent this when painting movement, use a clean, damp brush on stark lines to soften the edges.

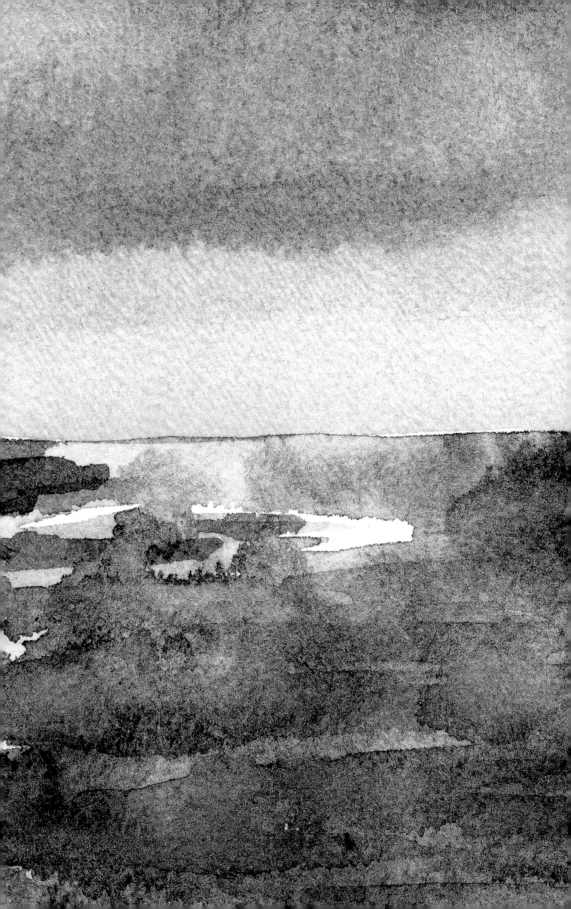

GET CREATIVE:

SKIES

Painting the sky is a fun way to paint something specific while getting to be as creative as you like. The sky can have almost any color in it, depending on the time of day depicted. Sunset, sunrise, stormy skies, northern lights—the sky truly is the limit!

Assignment

1. Picture a sky that evokes a strong emotion in you. Is it the wonder of a starry sky? The calm of a pink-and-orange sunrise? Maybe the excitement of blue and gray storm clouds building on the horizon? Keep the picture and the feeling it creates in your mind. Use that feeling to drive the creativity and inspiration for your painting.

2. To get the best blended effect when painting skies, make sure to paint wet-into-wet to allow the paint to flow together and avoid harsh lines. To paint clouds, you can use drops of water to create backflow or dab areas with a paper towel. Some clouds have hard edges too; to create this effect, go back over these areas with more pigment. For sunsets and sunrises, try to keep the paints flowing together in the same direction, and avoid patchy areas of color.

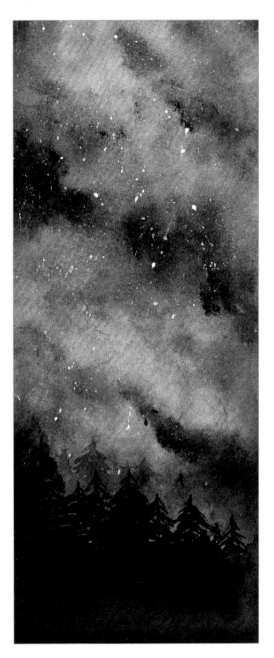

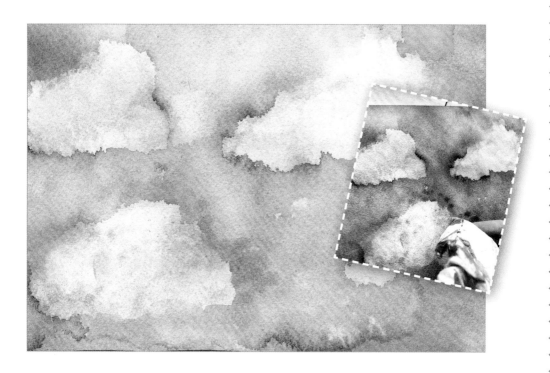

Keep in mind the location of the sun when choosing colors. The sky closest to the sun will look more orange, pink, and yellow (below). As you move away from the sun, the sky becomes more purple and blue (above).

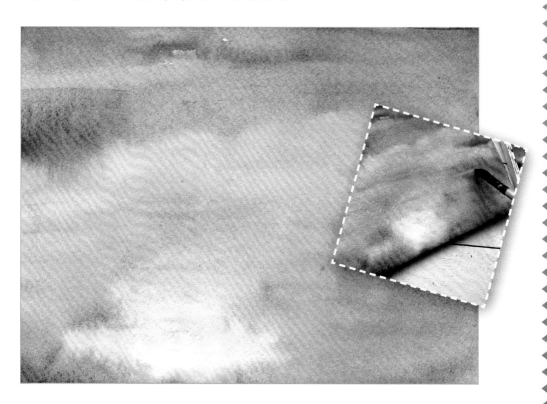

GET CREATIVE:

BUILDINGS

Buildings can feature many details, but don't let that overwhelm you! Take it one step at a time to create lots of layers for dimension.

Assignment

1. Find an image of a building that inspires you. With architecture, there's lots of room for interpretation and creativity.

2. You don't have to use a wash of flat brown paint to create a brown building; it can feature streaks of red and orange with yellow highlights. The shadows can be blue or even purple. Have fun with it!

3. Let your washes and your paint strokes dry fully before painting another stroke. This way, you can layer colors while still maintaining the colors and textures underneath.

Use a ruler to keep your lines straight. If you are working in a loose and free style, it's OK to freehand the lines instead. The wavy and slightly off lines will add to the overall organic feel.

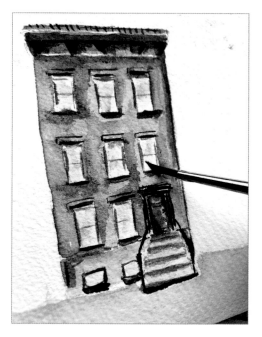

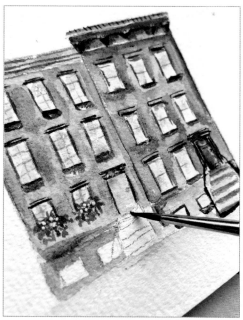

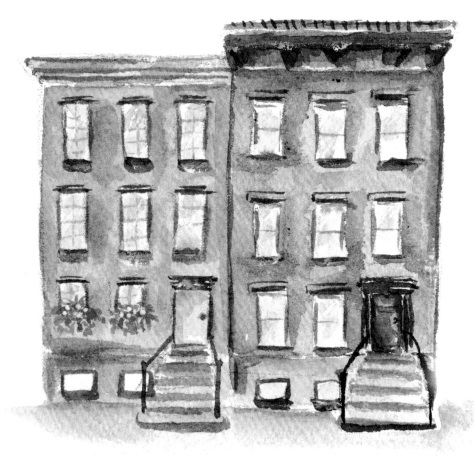

ABOUT THE AUTHOR

Kristin Van Leuven is a watercolor artist best known for her loose style and modern approach to painting. After trying different mediums, watercolor quickly became her favorite because of its unpredictable nature and blending ability. An Arizona native, Kristin is inspired by nature and the beautiful desert around her. After many years of painting, she was encouraged by family to post her work on social media, where she found a supportive community that has helped her artwork and business succeed. She is blessed with a loving husband and four beautiful children. Visit www.lovelypeople.bigcartel.com to see more of Kristin's artwork.

ALSO AVAILABLE FROM WALTER FOSTER PUBLISHING

Contemporary Color Theory:
Watercolor Flowers
978-0-7603-7503-7

Watercolor Painting at Home
978-1-60058-942-3

15-Minute Painting:
Effortless Watercolor
978-1-60058-924-9

Visit **quarto.com** • **walterfoster.com**